The Digital Compact Camera

The Digital Compact Camera

Release your compact's full potential

Mark Lucock

AMMONITE
PRESS

First published 2009 by
Ammonite Press, an imprint of AE Publications Ltd,
Castle Place, 166 High Street,
Lewes, East Sussex BN7 1XU

ISBN 978-1-906672-50-8

Whilst every effort has been made to obtain
permission from the copyright holders for all material
used in this book, the publishers will be pleased to
hear from anyone who has not been appropriately
acknowledged and to make the correction in future
reprints.

The publishers and author can accept no legal
responsibility for any consequences arising from
the application of information, advice or instructions
given in this publication.

A catalogue record for this book is available from the
British Library.

Editor Ailsa McWhinnie
Design Chloë Alexander

Colour origination by GMC Reprographics
Printed and bound by Everbest Printing Co. Ltd.

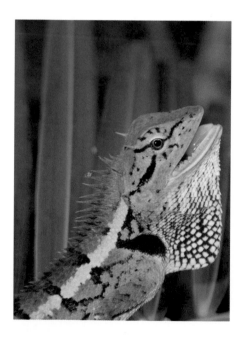

Contents

Introduction

In some ways, this is a long overdue book. Less than a decade ago, any traveller with a mind to visually document far-off lands will likely have toted (as a minimum) a couple of Nikon or Canon SLR film cameras, three or four lenses, a flashgun and two dozen rolls of film, all in a canvas camera holdall. This unwieldy complement of camera equipment was the staple used by a generation of artisans covering world conflict, culture, travel and nature.

How things have changed! A technological revolution in the last few years has destroyed this romantic image of what we might imagine a photojournalist to be: nowadays, low-cost, easily accessible and high-quality digital compact cameras have created opportunities for each and every one of us to participate as image gatherers. The photographic process has been democratized, and is now open to all.

For the vast majority of imaging, top-flight digital compact cameras can do an admirable job that exceeds all expectations associated with film SLRs of a decade ago. When I travel, I carry both a digital SLR and a prosumer digital compact camera. I work streets and crowds using the compact camera in a fashion that understates my goals. A digital SLR alerts those around you to your intention, and changes the character of the scene.

Being able to blend into a photogenic scene because of the diminutive nature of compact cameras is not the only attribute to herald. A prosumer compact camera at 10 megapixels can shoot macro images to 1cm, record wideangle scenes and reasonable telephoto vistas. It can record long (bulb) exposures to 15 seconds, balance flash and ambient light, allow one to alter ISO (sensor sensitivity to light) and yield files that can generate a 20in (50cm) 300dpi print when sympathetically rendered in a post-capture image-editing program such as Adobe Photoshop CS3. All this in a dinky package!

The twist in this tale is that while technology has empowered us to achieve high-quality photographs, technology is only half the story; the other half is 'inner vision' – you can't buy this, you need to grow it within you by perpetually reframing a composition in your mind's eye and learning to recognize what works and what does not. I hope that this book will open up new possibilities for you by teaching you the possibilities and potential for high-quality files from compact cameras and revealing how you can see a worthy picture in your mind's eye before you commit anything to your memory card.

By exploring case studies of my work, I hope this book will open your mind to untapped visual possibilities. My interest is travel, nature and landscape, and it is these genres that I would like to explore with you in this, my fifth book on photography. From the outset, it has been my intention that this book should not dwell on the technical, but rather engender a spirit of creativity that fosters an artistic approach to image making. That is to say, the emphasis is on why a picture needs to be taken and how to best compose a scene. The technicalities do obviously underpin the creation of the final image, but on their own cannot make a great picture, or compensate for prosaic vision.

The popularity of photography

It's hard to put a figure on an exact date when digital photography became mainstream, but if I had to opt for a year, it would probably be 2003/4. So this was the critical point where digital SLRs and compact cameras with good enough resolution opened up photography for the masses.

Things have only improved since then and the types of camera and photography I discuss in this book are available to almost everyone these days. When I started out as a nature and landscape photographer, writing my first books on the subject, this was a niche area – not any more! There are (apparently) somewhere around one quarter of a billion digital camera users in the world, with every second home in the developed world possessing at least one digital camera. Photography books of this genre are therefore no longer the specialist titles they once were.

Although I have been passionate about travel, nature and landscape photography for more than 25 years, it's only in the past four or five years that the digital photography revolution, and particularly the highly affordable and competent compact digital camera, has democratized the photographic process. Everyone is taking pictures – often very good pictures, many people also have extraordinarily effective home inkjet printers and so they are printing their artwork as well.

In parallel with evolving communication technologies such as the internet, photography has a changed role in society. The term 'citizen journalist' has been coined to describe anyone who carries a cheap digital compact camera or phone camera and who is in the right place at the right time to catch a newsworthy event. However, the immediacy and economy of digital capture and transmission, along with a population that spends ever-increasing lengths of time in front of computer screens means all photographic disciplines have, to a greater or lesser extent, evolved their own version of the 'citizen journalist'.

Let's face it; every one of us has the vanity needed to want to see his or her own work published. Indeed why not, particularly with the new media of online publishing. The internet has radically altered the economy of photography; it has made great images available to the world, but with so much choice available to picture buyers, it is inevitable that competition has driven prices down. But for you and me, photography has never been more fun, or more interesting.

Snakes for sale, street food stall, Cambodia.
It's hard to avoid the temptation of photographing exotic foodstuffs, and carrying a compact at all times means you don't need to miss any opportunities when they arise.

Canon A-Series Powershot at 21.7mm focal length, ISO 80, shutter priority, 1/60sec at f/3.5

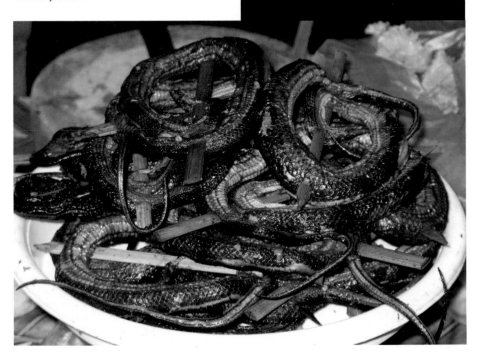

Which compact camera?

The type of compact camera you choose will probably fall into one of three categories which, to a certain extent, overlap.

- No technical thought necessary point and shoot

- Some rudimentary level of exposure control

- Complete manual (and automatic) exposure control

How to choose

Macro capability

Something important to me, but not necessarily important to everyone, is macro capability. My compact focuses down to 1cm and allows high-quality close-up images that were at one time only possible with highly specialized macro lenses and SLR-type cameras. True, the ease and speed of use of the macro facility on compact cameras falls short of a bespoke macro lens and DSLR, but it is nonetheless impressive. Not all cameras focus to 1cm – check specifications.

	Point and shoot (no technical knowledge required)	Point and shoot with basic manual control	Advanced digital compact with both automatic and full manual controls
Occasional user	● ● ● ● ●	● ● ● ●	● ● ●
Social outings	● ● ● ●	● ● ● ● ●	● ● ●
Wildlife	● ● ●	● ● ●	● ● ● ●
Landscape	● ●	● ● ●	● ● ● ● ●
Travel	● ●	● ● ●	● ● ● ● ●

Camera resolution

Pixel count is perhaps the factor most people think of first when surveying the marketplace for a suitable camera. This is an interesting issue as applied to compact cameras. Compact camera sensors are extremely small compared with DSLR sensors. Different compact cameras have different-sized sensors, and while some are a reasonable size, such as in the Canon Powershot A and G series cameras, others can be smaller.

Image quality is not just about pixel number; it is also about pixel size (pitch). The more pixels you squeeze onto a small sensor, the smaller each pixel (or photosite) becomes. This invariably leads to an increase in noise, and so there is a balance to be struck between pixel number and the pixel size. Too few pixels limit image (print) size, while too many pixels on a small sensor degrade the image by boosting noise levels (this increase in noise is due to the photosite signal needing more amplification).

Grey spider flower (*Grevillea buxifolia*). The macro function on many digital compact cameras is excellent, and opens up all sorts of creative possibilities.

Canon A-Series Powershot at 7.3mm focal length, ISO 50, aperture priority and macro, 1/80sec at f/3.2

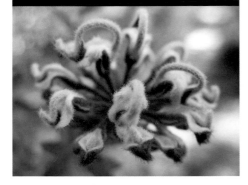

I have a 5-megapixel Canon A610 Powershot camera that won't print much beyond A3, but within that range all the camera attributes (lens quality, software algorithms, exposure) conspire to yield first-rate image quality. The 10-megapixel Canon A640 Powershot squeezes twice as many pixels onto the same-sized sensor – to good effect. It is important to read online reviews to establish whether a particular camera provides good image quality – note quality does vary – some cameras produce noisy, waxy, soft or overly sharpened files, while others turn detail to mush – so do check out critical online reviews.

A typical compact

The photographs on these pages show the layout of a typical high-end digital compact camera, including the sort of functions you can expect to come across.

FRONT VIEW

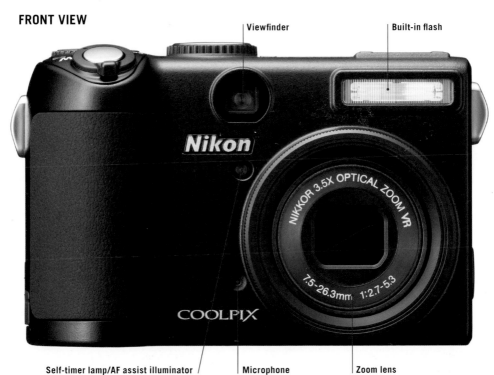

Viewfinder

Built-in flash

Self-timer lamp/AF assist illuminator

Microphone

Zoom lens

TOP VIEW

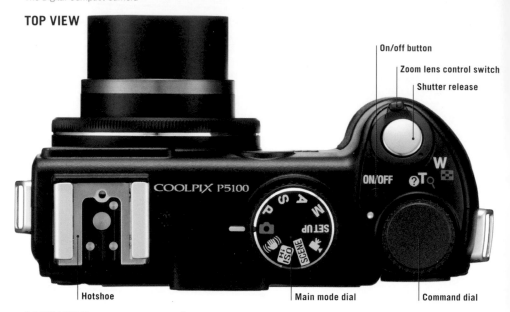

On/off button

Zoom lens control switch

Shutter release

Hotshoe

Main mode dial

Command dial

BACK VIEW

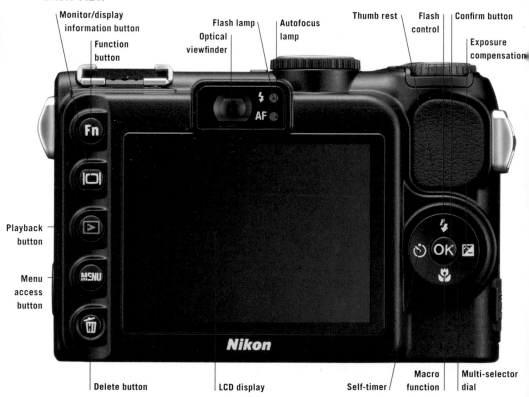

Monitor/display
information button

Function
button

Flash lamp

Optical
viewfinder

Autofocus
lamp

Thumb rest

Flash
control

Confirm button

Exposure
compensation

Playback
button

Menu
access
button

Delete button

LCD display

Self-timer

Macro
function

Multi-selector
dial

Digital film

All images are stored on removable memory cards. These vary in type, size and speed. Speed is not such an issue with compact cameras, but size and type are. By far the most popular card type for compact cameras is the SD (Secure Digital) format. Some compacts (Canon G6 as an example) use CF (CompactFlash) format. Others include XD or Sony's proprietory memory stick. I have never had a problem with SD cards, and now have a battery of several 2–4Gb SD memory cards. To put this in context, in a 7-megapixel compact camera, a 2Gb card will provide in excess of 500 images with the files set at maximum resolution. Can you remember how much space 15 rolls of film took up? (Still takes up if you are a film user!) At the time of writing a 2Gb memory card costs around £15/ US$25 – a lot less than the costs associated with buying and processing 15 rolls of Velvia film, the staple for a generation of landscape photographers.

The future looks very interesting. The biggest card I have is a 16Gb CF card. However, at the time of writing a new SDXC (extended capacity) format has been announced. Future generations of this card format will permit up to 2,000Gb of storage with speeds of up to 300MB/s.

Flexibility

Point and shoot compacts are designed to be foolproof, and often automate most if not all functions. I'm guessing this camera genre may not be top of the list for all people reading this book, but there is middle ground – I often carry (and am very attached to) a 7-megapixel Canon IXUS 70 – it takes high-quality images when used correctly. You don't have absolute manual control in the same way as more advanced compacts but you have enough control – you can select ISO, macro, flash on and off, and time exposures down to 15 seconds for long (bulb) exposures, for example of traffic tail lights at night. It also has a two- or 10-second delay in exposing to avoid shutter release blur.

This camera (along with many others) is designed as much as a fashion accessory as it is a photographic tool – it succeeds on both levels. Prosumer A and G series Canons offer the same level or exposure control as a DSLR (with the caveat that the longest exposure is 15 seconds). You have aperture priority (set the aperture and the shutter speed is automatically balanced), shutter priority (set the shutter speed and the aperture is automatically balanced for correct exposure), manual, program, auto and a variety of other options such as panoramic stitch assist and movie modes. What more could a budding travel or nature photojournalist want?

Lens considerations

As has always been the case, lens quality is paramount – look to the online reviews for guidance here. The focal lengths seem strange at first since they are much shorter than their 35mm film camera equivalents. This is to accommodate the smaller sensor area relative to what we had become accustomed to when using a 35mm film frame. This reduction yields very short focal length lenses with an almost infinite depth of field, even at apertures of f/4 and below. In fact, small apertures beyond f/8 are quite rare due to potential problems with light diffraction.

The increased depth of field with these small-sensor digital compacts is a major plus point for landscape photographers. I greatly value this attribute on my compacts, even though pleasing bokeh (the appearance of the out-of-focus areas of the image) is harder

Image stabilization

A recent innovation taken up by compact camera manufacturers is image stabilization (IS). IS permits use of cameras at slow shutter speeds and with long lenses, conditions that otherwise tend to result in blurry images. It works by shifting a special floating glass element in the lens to compensate for hand tremor – the image is thus corrected and hits the sensor as a still rather than moving scene. While this helps render sharp images in low light and or with long lenses, it does nothing to help freeze moving subjects. If you have a choice of IS on non IS – go for IS, it is, without question, a significant advantage.

to create. At the end of the day, all that has happened is that a lens perspective equivalent to 35mm has been retained despite a drop in lens focal length and an overall increase in depth of field.

Power issues

Often-overlooked aspects of buying a compact camera are battery life and battery type. Some cameras drain batteries very quickly, others are very economical. Check on this before buying. A question many people anguish over is battery type – one-use AA or rechargeable lithium-ion. This is a personal thing. I favour cameras that employ one-use alkaline AA batteries because

they are universally available, more convenient and do away with long-ish recharging times that can hamper one when travelling. Others condemn cameras that use AA batteries. Li-ion batteries also tend to have a finite lifespan (number of recharge cycles) and can be expensive to replace.

AA batteries are cheap when bought in economy packs and certainly in the Canon Powershot A640 I presently use, last a very long time before expiring. My main issue on batteries is the absence of a camera gauge to monitor battery life on some cameras. A warning simply appears just before the camera batteries die – not always helpful.

File recording format

Unlike DSLRs, compact cameras generally only offer image capture in one format – JPEG (Joint Photographic Expert Group). JPEGs are fine providing you understand their limitations. JPEGs can be compressed easily for storage and transmission, but in so doing quality is lost. JPEGs also deteriorate every time they are saved. The way forward is to capture in JPEG, enhance in post-capture editing software, and save as a TIF (Tagged Image Format) which, although larger, is a more robust format.

Some, more advanced, compact cameras do give you a choice of RAW or JPEG. RAW files allow you to alter settings post-capture to improve the image file. You can modify white balance, contrast, saturation and sharpness to mention but some of the parameters. I shoot exclusively RAW on my DSLRs, but only shoot JPEG on my compact cameras, even if RAW is available – as with some Canon G-series and Nikon P-series cameras.

Conclusion

As with most things in life, you need to balance the limitations against the positive attributes afforded by this genre of camera, and decide what best suits you. I'm a real fan of prosumer campact cameras, as they deliver the goods in a lightweight unobtrusive package that permits candid shots in street markets, while also providing exceptional quality for intimate landscapes – waterfalls, rivers and buildings etc. The same photographic tenets apply, as

Street vendor, Bangkok, Thailand.
Shooting digitally means you can take a lot of pictures without worrying about wasting money. That's no reason to rush things, though. By concentrating on the scene in front of me, I was able to achieve a clean composition that makes the most of the colour within it.

Canon IXUS at 17.4mm focal length, ISO 80, 1/60sec at f/4.9

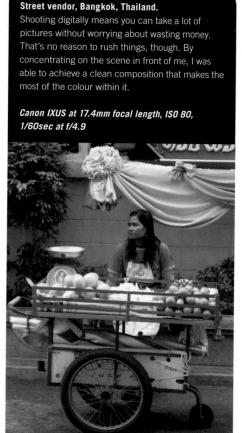

has always been the case. You need to use a tripod, avoid harsh contrasting lighting and learn some basic rules on composition.

The pages that follow demonstrate just what is possible – many of the images that I have selected are treated as case studies, and the book itself is broken down into three basic sections – travel, nature and landscape. Before continuing, however, I feel duty bound to remind you that the best photographers explore the world with their cameras in a fashion that downplays their purpose. Just consider the intrusive condescension of a wealthy western photographer invading the personal space of an impoverished third world individual who could only dream of owning a camera themselves, and who probably struggles to put food on the table each day.

Rainforest giant with huge buttress roots (*Diospyros rhodocalyx*).
Walking in the rainforest can be exhausting, but there's no need to carry a full complement of DSLR kit when modern compacts are so efficient.

Canon A-Series Powershot at 7.3mm focal length, ISO 50, aperture priority, 1/10sec at f/5.6

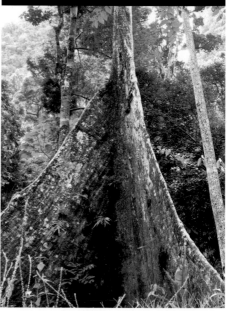

Overtly shooting a colourful local as a main subject without first seeking permission is arrogant and potentially humiliating for that person. Always be polite, courteous, know when to back off, and apply your craft with subtlety and empathy while at the same time engaging with your subject to make the whole process fun and lighthearted.

Buddhist monk with cigarette.
Shooting with a compact camera allows you to be discreet and move quickly to capture fleeting moments such as these.

Canon A-Series Powershot at 12.6mm focal length, ISO 80, aperture priority, 1/125sec at f/3.5

1 Travel

Introduction

Travel with your digital compact camera

For many people, each year will include a major holiday and a few short breaks. Whether your destinations are exotic or familiar, there will likely be a wealth of photographic opportunities on offer. Aim to extract the essence of a place with your imaging – the objective should always be to produce something that engenders emotion in the viewer – transport them to the location you shot, let them feel the spirit of the place that led you to that location or scene and that created the raison d'être for tripping the camera shutter.

It's probably good to be honest about travel photography as a genre. A great many images that lure the viewer to a sunny, beautiful location far from the dreary humdrum of everyday life are nothing more than an abstraction of reality, an idealized moment in time that has excised all that is ugly, incongruous and distracting from the broader vista - they have been constructed to sell a dream. Truth is that a dream vista taken on a moderate telephoto lens can become a nightmare if rendered on a wideangle lens. The palm tree and sandy beach look good compressed via a telephoto lens, but on a wideangle lens you see the sprawling metropolis, hordes of tourists, airport, busy road or other less than romantic content. Abstraction can also work by time of day, a heaving beach is not photogenic – an empty one is. No prizes for guessing how many idyllic beaches are shot at dawn to avoid the crowds and plethora of sandy footprints – then given a saturation boost in Photoshop to give a more desirable (saleable) colour temperature to the scene.

At some time we have probably all been taken in by the illusion of paradise conjured up by a beautiful magazine photograph – I certainly have – and, like many people, was very disappointed by the harsh reality of a place. A year ago I was all fired up about a boat excursion to Ko Phi-Phi Leh Island in the Andaman Sea. I wanted to see where the Leonardo di Caprio film, *The Beach*, was made – all pictures of the lagoon at Maya Beach on Ko Phi-Phi Leh were jaw dropping. When I arrived there, dozens of boats were already moored and several hundred tourists massively overwhelmed the natural beauty – I never took a single image, such was my disappointment. It's not always easy to create paradise on film – even in paradise.

In your own personal photography, remember, the image may not necessarily reflect reality – indeed the best images often do not, they show a place in the best light, at the best time of day and from the best vantage point. In other words try to dress the place up in its Sunday best!

Remember, travel photography and the signature of a country or region is as much about people and culture as it is about buildings and well-recognized landscapes, so make sure that your photographic portfolio encompasses all of these varying subjects – if you do, you should return home with a bountiful harvest of images.

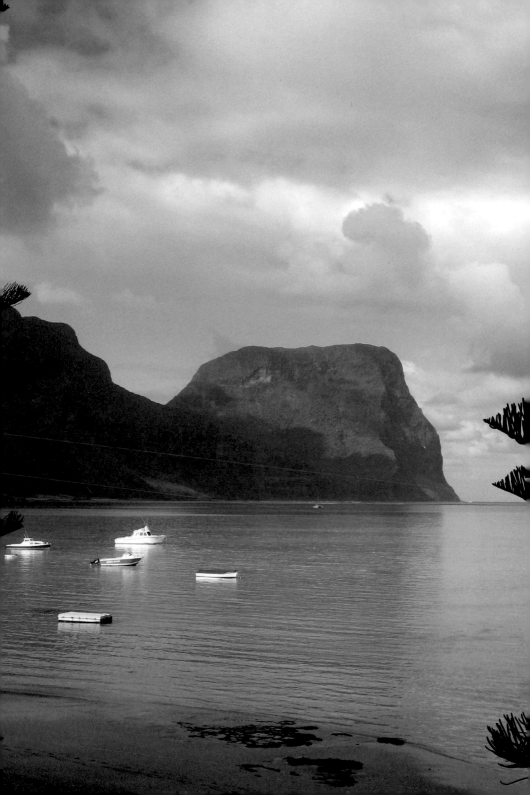

A balanced composition

Keep it simple

This image combines the three components most people gravitate towards on a holiday: blue sky, sandy beach and warm sea. I shot this scene with a tripod, but didn't really need one as the shutter speed was quite fast.

This is one of a series I shot with the intention of creating a triptych. I wanted to create a scene that whets the appetite for the seaside. This picture is generic, and it really doesn't matter where in the world it is. The main point is that it is not Blackpool on a cold February afternoon. Examine the harmonious balance between the three elements in the picture – I shot many files this day that did not exhibit the right balance, and these were rejected. Bright sun, particularly on beaches where light reflection can be high, often fool a camera into underexposure. This clearly was not the case here, indicating how far camera technology has evolved in recent years.

Subject	Wamberal Beach, New South Wales, Australia
Camera type	Canon A-Series Powershot (prosumer type)
Pixels (x10^6)	7.1
Focal length	7.3mm (35mm on 35mm film format)
Exposure mode	Aperture priority
Aperture	f/5.0
Shutter speed	1/1000sec
ISO	80
Tripod	Yes
Flash	No
Additional points	Tripod used, but not really needed.

Case Study 02

Look for symbolism

Nature subsumes human endeavour

As a photographer, I have to balance the obvious need to shoot classic views of recognized travel/landscape icons with the requirement for searching out ever-more original renditions – even if these are of fairly well-known locations. Seeking out new views/subjects is never easy. This stone Buddha head being suffocated by a strangler fig was an unexpected find – a real gem, as it's photographic potential is enormous. I shot it at various focal lengths and in both vertical and horizontal format: virtually all exposures produced the goods – an image with immense potential as a fine-art print, and one that screams the merits of travel in Southeast Asia. As you will see later, some images require very mindful composition – not here, though; place the head centrally, and expose away at different zoom settings. The only important photographic point to note was that I employed a tripod, as shutter speeds were quite low. This was not optional – it was mandatory.

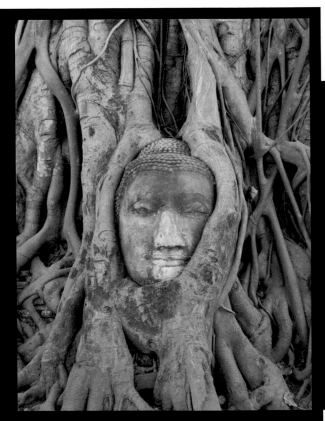

Subject	Ayuthaya, Thailand
Camera type	Canon A-Series Powershot (prosumer type)
Pixels (x10^6)	10
Focal length	9.6mm (46mm on 35mm film format)
Exposure mode	Aperture priority
Aperture	f/4.5
Shutter speed	1/13sec
ISO	80
Tripod	Yes
Flash	No
Additional points	I used a two-second time delay to avoid camera shake when depressing the shutter.

Choosing perspective

Create order from chaos

These pigs' heads were shot in a frenetic Asian market. It is not a scene often encountered in the west and hence I was keen to record it. In this kind of situation most people armed with a digital compact would point and fire, relying on the camera and, in this dim environment, flash. However, chances are it won't render a good image as flash light falls off quickly and has limited capability for illumination in large, dim spaces. It also causes local hot spots of light that can, and often do, look pretty awful.

To succeed in this shot, once I had the composition right, I braced my compact camera on a vertical wood beam supporting this butcher's stall, turned off the flash and used aperture priority exposure. As I only ever use the lowest ISO setting to reduce sensor noise and eradicate grainy images, the shutter speed was way too long to handhold.

I could have resorted to a tripod, but the aisles were frenetic – far too busy to allow this. It probably took five minutes in all to extract this view from all the chaos in the market and without doubt the hardest part of the exercise was finding a composition that worked and yet still allowed me to brace the camera effectively. for the long exposure that was required.

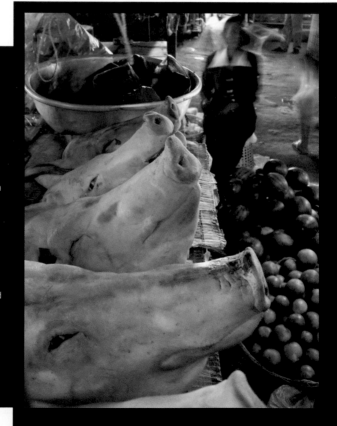

Subject	Pigs' heads at an Asian Market
Camera type	Canon A-Series Powershot (prosumer type)
Pixels (x10⁶)	10
Focal length	7.3mm (35mm on 35mm film format)
Exposure mode	Aperture priority
Aperture	f/2.8
Shutter speed	0.8sec
ISO	80
Tripod	No, but braced firmly against wooden post
Flash	No
Additional points	I used a two-second time delay to avoid camera shake when depressing the shutter.

Case Study 04

Take control

Shooting iconic destinations

It's hard to take a bad photo of the Blue Mountains. To execute this scene, I steadied my camera by resting it against a safety barrier. Part of my rationale for drawing attention to this is the frustration I feel whenever I see a gaggle of tourists snapping away at these kinds of grand vista using a compact camera and flash for illumination. The range of most built-in flashguns is a few feet, let alone half a mile or more. Take control – switch off the flash,

select a low ISO, brace the camera and gently trip the shutter. If you don't have a convenient barrier to support the camera, invest in a lightweight, cheap tripod that folds small and fits easily into a small day pack – but, to be of any real use, ensure it comes with a quick-release platform for ease of operation.

Subject	Govetts Lookout and Pulpit Rock, New South Wales, Australia	**Exposure mode**	Aperture priority
Camera type	Canon A-Series Powershot (prosumer type)	**Aperture**	f/5.0
		Shutter speed	1/30sec
		ISO	50
Pixels (x10^6)	5	**Tripod**	No, but braced firmly against a safety barrier
Focal length	7.8mm (37mm on 35mm film format)	**Flash**	No

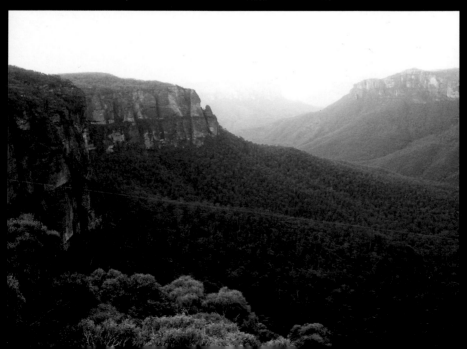

Converting to sepia

Enhance the sense of age

I selected this example as it allows me to do two things; explain the artistic merit of the composition and compare the quality of a 6-megapixel DSLR file with a 10-megapixel compact camera file. The subject shown here is iconic and familiar to most people around the world from films such as *Tomb Raider*. It is, in fact, the ruined temple of Ta Prohm in Cambodia. Before I go any further, let me use this example to reinforce my earlier comments about how many iconic images abstract an idealized version of reality. The scene looks as if it exists in the middle of a remote tropical jungle, unseen by human eyes for a millennium or more. Think again. When I shot this scene, I was shoulder to shoulder with at least 75, possibly even as many as 100 other tourists.

Tempers can fray easily in the heat and humidity. Many people want to have their photos taken next to the fig tree roots, others

Subject	Ta Prohm, Cambodia	ISO	100
Camera type	Canon 6-megapixel DSLR	Tripod	Yes
Pixels (x10⁶)	6	Flash	No
Focal length	40mm		
Exposure Mode	Aperture priority		
Aperture	f/8.0		
Shutter speed	1/8sec		

Pixels (x10^6) 6

Additional points Cable release used. For those who follow in my footsteps, this tree is almost equally photogenic from the other side of the wall – and tourists should be thinner on the ground.

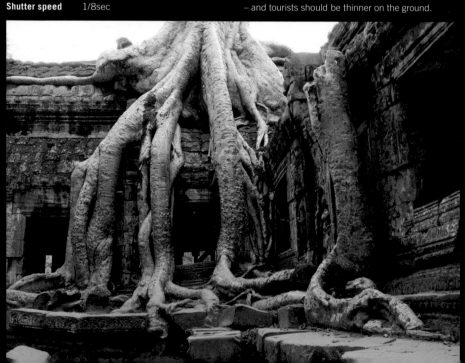

want to shoot high-quality images of the tree and ruins without any modern intrusions, particularly of other tourists – frustrations abound. I patiently waited for the throngs to dissipate, but even then only found two or three minutes to shoot before fresh hordes returned. Clearly, the evocative and alluring images one sees of the strangler fig tree at Ta Prohm hide the truth of what this place is really like – busy, indeed heaving.

Composition-wise, one has essentially two main choices – either a horizontal perspective with the strangler fig tree placed centrally in frame, or vertical format with the strangler fig tree dominating the width of the scene. These were my immediate choices as I saw it in my mind's eye. I would like to have worked the scene to find new viewpoints, but given time constraints due to all the other tourists at Ta Prohm, and a strict 'out before dusk' policy, I stuck with the most obvious (and clichéd) compositions. In terms of file quality, I see little to criticize in the 10-megapixel compact file compared with the 6-megapixel file – the final interpolated print size being 20x15in (50x38cm) and 24x16in (60x40cm) for the compact and DSLR respectively. The DSLR employed a very high-quality 17–40mm L-series Canon lens. Both cameras were supported by a tripod and while the DSLR was tripped with my cable release, the two-second time delay function tripped the compact.

Subject	Ta Prohm, Cambodia	Shutter speed	One second
Camera type	Canon A-Series Powershot (prosumer type)	ISO	80
		Tripod	Yes
Pixels (x10^6)	10	Flash	No
Focal length	7.3mm (35mm on 35mm film format)	Additional points	I used a two-second time
Exposure mode	Aperture priority	delay to avoid camera shake when depressing	
Aperture	f/7.1	the shutter. Converted to sepia in postproduction.	

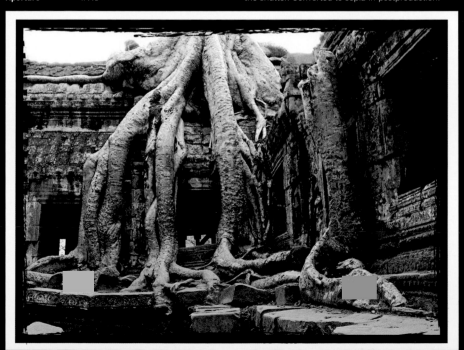

The rule of thirds

A classic approach

All the classic rules of composition apply when creating seascapes like this, which are generic fodder for the myriad travel brochures and travel websites produced each year. Foreground interest comes in the form of a large rock, which immediately focuses the viewers' attention and anchors the scene. The horizon is approximately one-third of the way down from the top of the frame. This is consistent with the rule of thirds, which states that, generally, the most satisfactory and dynamic compositions are obtained by dividing the frame up with two imaginary lines dropped down one-third of the

way from either edge of the frame and again with two lines bisecting the image laterally, one-third up and down from the top and bottom of the frame respectively. By placing the primary point of interest at any of the line intersections, you should have a composition that works well. Which of the intersections you select depends on the nature of your subject and the secondary features that are also contained in the landscape. Strong upright features also work well if placed on the vertical lines one-third of the way from either edge, while horizons look best when placed on the horizontal line one-third from the top.

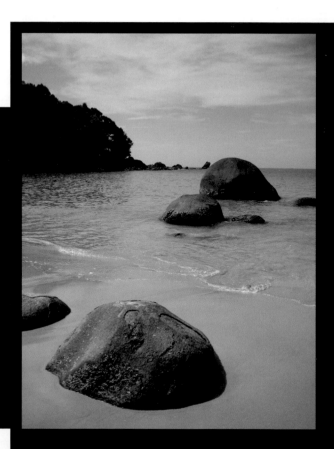

Subject	Khao Lak-Lam Ru National Park, Thailand
Camera type	Canon IXUS-Series (consumer type)
Pixels (x10^6)	7.1
Focal length	5.8mm (35mm on 35mm film format)
Exposure mode	Manual*
Aperture	f/8.0
Shutter speed	1/320sec
ISO	80
Tripod	No
Flash	No
Additional points	*Although nominally manual, in reality, on this camera, this is a fairly automated exposure mode.

Case Study 07

The grab shot

Capture local colour

Good travel photography needs to engender wanderlust in the viewer. This image is just such an example, and shows a young girl canoeing her way around a rustic and remote floating village – actually a village propped high up on stilts to accommodate the wet-season downpours, and ebb and flow of the mighty Mekong River that massively swell the local lake (Tonle Sap) on which this village (Kampong Phluk) subsists. The child and her canoe are placed on a line cutting through the lower third of the scene. This positioning is perfect based on the rule of thirds matrix. She is perfectly focused and, as the main element of interest within the scene, anchors the village environment within the frame. This picture captures the dynamics of everyday life in this culturally fascinating village – it encapsulates the mood and is not staged.

Subject	Kampong Phluk, Cambodia	**ISO**	80
Camera type	Canon IXUS-Series (consumer type)	**Tripod**	No
Pixels (x10⁶)	7.1	**Flash**	No
Focal length	5.8mm (35mm on 35mm film format)	**Additional points**	*Although nominally manual,
Exposure mode	Manual*	in reality, on this camera, this is a fairly	
Aperture	f/2.8	automated exposure mode. Shot one-handed	
Shutter speed	1/400sec	from another boat.	

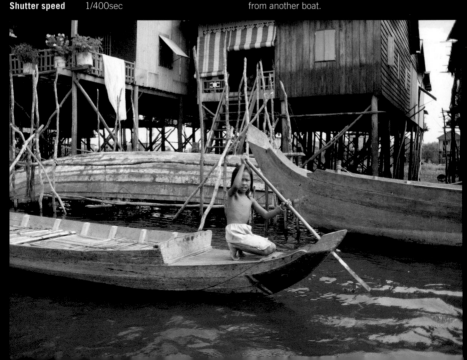

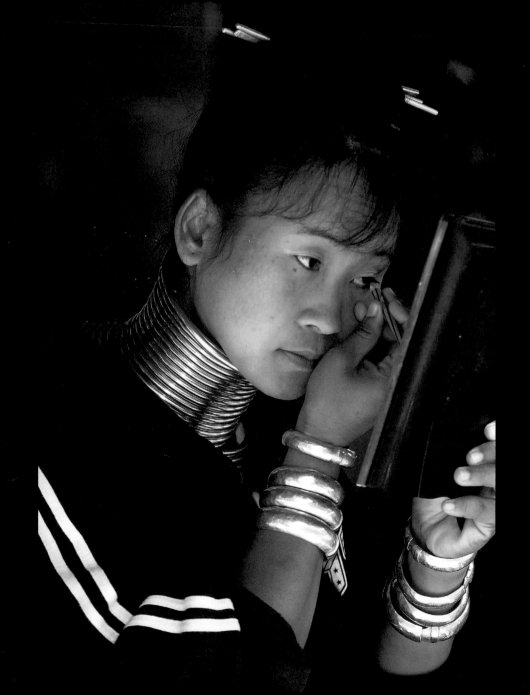

Photography masterclass
Capturing the essence of the moment

This woman is part of a hill tribe that originates in Burma. The neck rings are solid brass and very heavy; they depress the collarbones, giving the impression of a long neck. Whatever you might think of this practice it still continues and, while not in line with ethical thinking in a modern contemporary society, it helps bring in significant tourist dollars, so is unlikely to stop any day soon.

The Padong start this practice as early as five or six years of age. I love this picture because it shows an intimate moment away from the tourists, and provides a sensitive and sympathetic portrait with a difference. The secret is to use the long end of your zoom lens and to get the subject familiar and desensitized to the presence of your camera. This probably means wasting the first few frames.

Always seek permission for this kind of image. This kind of picture is very easily achieved with a good compact camera – all the better if it has image stablization built in.

Motion blur

Colour and movement

Travelling through Buddhist countries, one cannot fail to notice all the bright orange-robed monks. With this image I wanted to create something a bit different, yet still provide a colourful and dynamic reflection of this faith. It was taken while I was having breakfast at a street café. The monk walked past and I did nothing more than pick up my compact camera and pan left to right, tripping the shutter as I did so. As default settings, my ISO is always as low as possible and flash off, which is ideal for making this kind of image. The resulting picture works well and, if there is a message to be learned, it is to look for the unusual and unlikely, and not to be afraid to experiment.

Compact tip
*Keep it simple.
I find I achieve better
results if I travel light.*

Subject	Panned shot of monk walking
Camera type	Canon IXUS-Series (consumer type)
Pixels (x10^6)	7.1
Focal length	17.4mm (105mm on 35mm film format)
Exposure mode	Manual*
Aperture	f/4.9
Shutter speed	0.3sec
ISO	80
Tripod	No
Flash	No
Additional points	*Although nominally manual, in reality, on this camera, this is a fairly automated exposure mode. Shot by panning – keeping camera in sync with the movement of the monk for the duration of the longish exposure time.

Case Study 09

Time exposures

Night shots

There are perhaps half a dozen vantage points for shooting the Sydney Opera House, although some of these require a good telephoto lens. As I only had a 5-megapixel compact with me I opted to shoot it close up. To achieve this perspective I used a small 8in flexible tripod to brace the camera against the outside of a concrete wall and the two-second shutter delay to avoid camera shake when depressing the shutter release. The secret was to shoot in manual mode and bracket the shutter speed all the way down to 15 seconds. I obtained three or four good shots with this approach. However, as the tripod was at a 45-degree angle over the water, I needed to actively apply downward force to the tripod to keep it stable. Notice how the image is well balanced with the moon above and colourful water below. Always ensure the elements within the frame are composed harmoniously before tripping the shutter.

Subject	Sydney Opera House, New South Wales, Australia	**Exposure mode**	Manual	
Camera type	Canon A-Series Powershot (prosumer type)	**Aperture**	f/8	
		Shutter speed	Six seconds	
Pixels (x10^6)	5	**ISO**	50	
Focal length	13.6mm (65mm on 35mm film format)	**Tripod**	Yes – small flexipod	
		Flash	No	

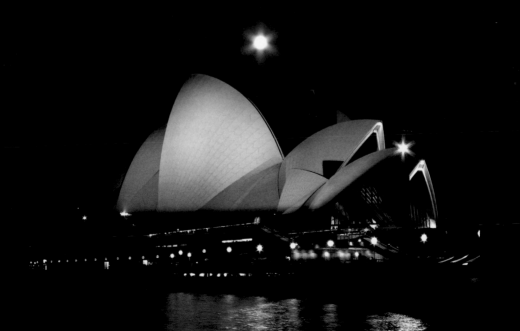

Balancing light

Twilight and artificial

Some of the best cityscapes are taken as the light crosses over from day to night – a critical dusky period of maybe ten minutes exists before the sky becomes too inky blue, but yet all the city lights have been switched on creating a kaleidoscopic feast of colour. Catch this moment with the right composition and you are guaranteed a winning shot. I tried to do this in Bangkok with Wat Arun, the tallest religious building in the city. I found a suitably quiet location on the other side of the Chao Phraya River from the temple, set my tripod up on a concrete wall and shot a series of images using the two-second shutter delay as the sun went down. I shot frames in both aperture and shutter priority mode, but find I tend to get better results when I use shutter priority for very long exposure night scenes. The best cityscapes taken at night require that the flash is off and ISO low, and a tripod or support of some kind is absolutely mandatory.

Compact tip

Always keep your crude/RAW files somewhere safe – these are your most important photographic asset. Always have a backup of your image files in a separate location.

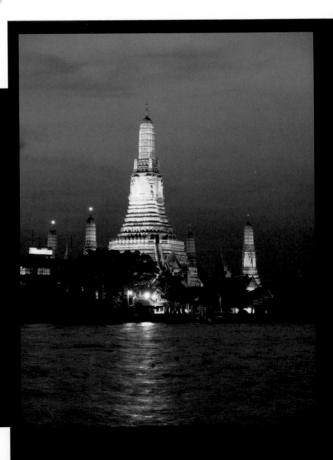

Subject	Wat Arun, Bangkok, Thailand
Camera type	Canon A-Series Powershot (prosumer type)
Pixels (x10^6)	10
Focal length	21.7mm (104mm on 35mm film format)
Exposure mode	Shutter priority
Aperture	f/3.5
Shutter speed	One second
ISO	80
Tripod	Yes
Flash	No
Additional points	I used a two-second time delay to avoid camera shake when depressing the shutter.

Case Study 11

Turn off the flash

Brace your camera instead

Markets are all about sensory overload: smells, colour, crowds, noise. How do you record a bustling nexus like this on your compact camera? There is no single answer to this. What I did was to find a metal supporting strut for a stall that faced onto the main fruit and vegetable aisles. I turned off the flash, selected the lowest ISO and wideangle end of the zoom. I used the strut to brace the camera after finding the best composition, and took half a dozen images to ensure a couple of successful ones.

Compact tip

Don't put all your eggs in one basket. Instead of carrying a few very large memory cards when on an extended shoot, carry many smaller and medium-sized ones. I prefer a dozen 512Mb, 1 and 2Gb SD cards to 4 or 8Gb ones. However, 4 and 8Gb is the preferred size for my DSLRs where large RAW files soon fill up a CF card.

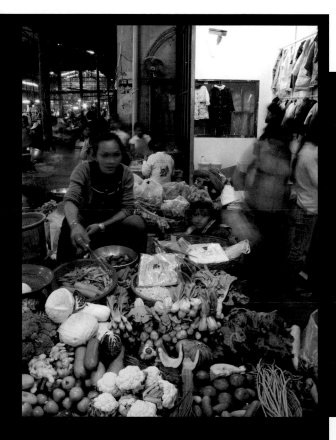

Subject	Southeast Asian market
Camera type	Canon IXUS-Series (consumer type)
Pixels (x10^6)	7.1
Focal length	7.3mm (44mm on 35mm film format)
Exposure mode	Manual*
Aperture	f/5
Shutter speed	One second
ISO	80
Tripod	No, but camera firmly braced against a vertical metal post
Flash	No
Additional points	*Although nominally manual, in reality, on this camera, this is a fairly automated exposure mode.

The classic composition

In order to transform an ordinary scene into a powerful composition, you should get low, and select the wideangle end of your zoom – use a tripod (as here) if light levels are too low to handhold. Compose with colour and compositional techniques such as the rule of thirds in mind as this generally gives the most satisfactory and dynamic composition.

Divide the frame into an imaginary grid of nine equal rectangles. Now place your primary point of interest at any of the line intersections, and you will have a composition that should work well. Which of the intersections you select will depend on the nature of your subject and the secondary features that are also contained within the composition.

Strong vertical features also work well if placed on the vertical lines one third of the way from either edge, while horizons look best when placed on the horizontal line one-third of the way from the top of the frame. As you can see, the pivotal point on this fishing boat is in the lower right section of the frame.

Local colour

Focus on the exotic

I was having supper after a long day trekking around archaeological sites when I noticed a street stall next door to the restaurant I was patronizing. The stall was selling an amazing, and by western standards, bizarre array of foods – two forms of cooked snake, one whole and skewered, one diced and sliced, fried crickets, fried insect grubs and other exotica. Of course all this needed recording, and I used a 10-megapixel compact on a tripod to achieve this night shot. The pavement footfall was constant, so I needed to keep moving the tripod and grab my shots in between the pedestrian traffic. The exposures were long and this was no bad thing, since having asked permission to shoot the stallholder, she was too conscious of the camera; her movement blur implicit in the long exposure overcame this problem of not knowing how to respond to the camera.

Subject	Street food stall, Cambodia	**Shutter speed**	One second
Camera type	Canon A-Series Powershot (prosumer type)	**ISO**	80
		Tripod	Yes
Pixels (x10^6)	10	**Flash**	No
Focal length	7.3 mm (35mm on 35mm film format)	**Additional points**	I used a two-second time delay to avoid camera shake when depressing the shutter.
Exposure mode	Shutter priority		
Aperture	f/2.8		

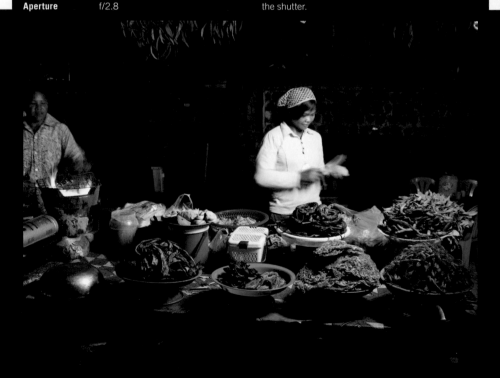

Case Study 13

Break the rules

Take a different view

When we travel we tend to home in on tourist hotspots. Despite this, there is no reason to reproduce clichéd images of these places. I think this image works well when angled away from the perpendicular and, although it may appear simple, the mythical, beast-like guardian of this sacred place took a dozen shots before I was happy with my composition. It's difficult to articulate why this does work and the other 11 don't. I guess it's all about proportion and perspective. If it looks right, it probably is right.

The sun was fierce and no tripod was necessary. It was simply a question of setting the camera to aperture priority (f/3.5–4 on this model seems to yield very sharp images), a low ISO, composing and shooting. Working this wonderful place that offers such an amazing feast for the eyes and photographic potential for the camera, I was very much aware of how liberating it is to be freed from the financial constraints of film. Digital capture on a 2Gb SD card gives one the scope to experiment and record every facet of such wonderful places.

Subject	Bestial guardian of Wat Phra Kaew, Bangkok, Thailand
Camera type	Canon A-Series Powershot (prosumer type)
Pixels (x10⁶)	10
Focal length	12.6mm (60mm on 35mm film format)
Exposure mode	Aperture priority
Aperture	f/3.5
Shutter speed	1/1000sec
ISO	80
Tripod	No
Flash	No

Additional points Another approach is to isolate a dominant feature of a busy scene. In another image I closed in and isolated the head of the mythological beast.

Travel with your compact

The days when I had to find room in my hand luggage for 100 plus rolls of film are history – thank goodness! However, what we now take on our travels is so different, a time traveller from as recently as 2003 wouldn't believe just what a sea change has taken place in the industry, and how the ramifications of this have empowered the average travelling snap shooter, let alone the professional travel photographer – more freedom for the individual and less work for orthopaedic surgeons!

The way we collect images has obviously changed, and is in part the raison d'être for this book. However, while compact digital cameras are small and capable tools for recording so perfectly the many aspects of one's travels, the real changes are in how we store, process and share images en route.

To illustrate what I mean – five years ago, a trip to the USA would have entailed taking along 150 rolls of Velvia film – mostly 120 rollfilm, but plenty of 35mm film too. I would have a 35mm point and shoot compact camera, a 35mm SLR with three lenses and either a 6x9 or 6x7cm rangefinder medium-format film camera.

In the last few months I've visited Tasmania, Laos, Malaysia and northern Thailand. What comes with me? My Canon Powershot point and shoot digital camera, and one digital SLR with a wide to moderate tele zoom, and one longer zoom for wildlife. This takes up much less room than my older film cameras, and with today's full-frame digital SLRs, image quality is as good as ever it was (better, actually) and, with my digital compact camera, I often end up with far better pictures than I did on my 35mm SLR film cameras.

My basic travel kit now comprises a DSLR with two lenses, and a digital compact camera.

Netbooks

However, the real change comes with replacing film with memory cards. Even 32Gb cards are affordable these days, and with the advent of netbooks – mini laptops that are incredibly small, but adequate to run programs like Adobe Photoshop CS3 with relative ease – one can start sifting through images, and optimizing them as soon as you've take them. I was in Laos recently and used my truly brilliant Acer Aspire One netbook to create some great photomerges.

Usually I do all this at home, but the diminutive Acer netbook takes up little room and fits easily in my camera bag, in a section I usually reserve for camera manuals. It has travelled a fair bit and takes all the trauma of travel in its stride. Couple the on-board 160Gb hard drive with a 120–250Gb USB-powered external drive for backup and you can create inbuilt redundancy, and not worry about losing image files – just store the drive and net book in different cases in chance of theft.

I never liked the idea of traveling with full-size laptops – they are pricey and cumbersome, plus a target for thieves. Netbooks are small by comparison, and can easily be concealed from prying eyes; they are also cheap – about the same as a top-line digital compact camera. Other manufacturers of netbooks include, Asus (Eee), Sony, Lenovo, HP and Dell. By the time you read this, you can guarantee others will have joined suit, and this genre will have become even more technically refined.

Sharing images

Of course, image storage and editing are only two things that a netbook opens the door to. Others include an ability to send and receive emails (if that's actually what you want on a 'get away from it all' holiday!), access the internet to find, book and confirm onward flights and hotels, and perhaps most interestingly to access social network sites

The handy size of the average netbook becomes apparent when you see its scale against something like a pen.

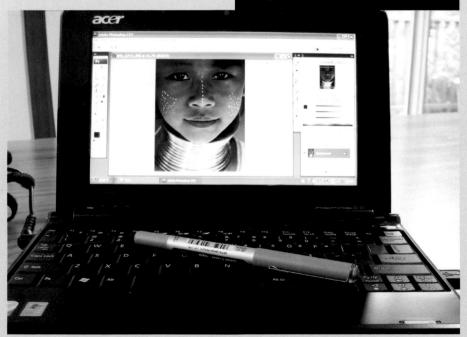

that allow you to store (upload), organize, edit and share your images with friends thousands of miles away. The best known of these are probably Yahoo's Flickr (flickr.com) and Google's Picasa (picasa.google.com). I've seen some great holiday photos that friends have posted to these sites, but I don't personally use them, preferring offline storage.

Having said this, and feeling like a bit of a Luddite, I do feel that professional-level imagers will probably prefer my approach, while for less serious work, network sites are simply brilliant. I'll go as far as to say they represent some of the most inspiring places to visit online if you are planning an outing and want to scope the photographic opportunities that you might be afforded when you arrive.

I have some favourite places for photography that are local to where I live, and think I have extracted some of the best images I could of these locations. A quick visit to Flickr – and following a keyword search – I'm shown that others have photographed these places far better than me. Don't get me wrong, though, there is plenty of so-so imaging there (and I'm being polite when I say that).

Earlier I alluded to the problem issue of digital photography – democratization. Too many mediocre images mask the cream of the crop. The other aspect is that you soon realize from online browsing that there are plenty of people out there capable of taking far better

pictures than the big names in nature, travel and landscape photography. Whether they have consistently good output or a varied collection of images is another matter. Suffice to say I'm humbled by the amazing images I see online almost every day.

Portable hard drives

I now don't travel without my netbook which, at least for me, has taken over from the other option – a bespoke stand-alone hard drive to download memory cards to. Some of the manufacturers that supply these include Epson, Jobo and Wolverine.

Some of these drives double as MP3 players and allow video, but obviously fall short in the diversity of utility available when compared with a netbook. However, I won't be throwing my Epson away just yet. I shoot both RAW and JPEG simultaneously on digital SLRs, but can only edit the JPEGs on my netbook – RAW files must wait till I get home. The reason for this is that the screen resolution is too low for my particular RAW conversion software to install. However, this is a minor inconvenience, and most people shooting on

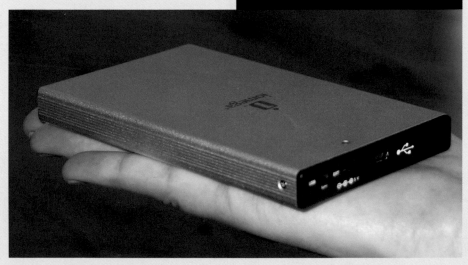

When compared with several dozen rolls of 120 and 35mm film, the portable hard drive is convenient and lightweight.

a digital compact are likely to use JPEG as their default file format, and so this is not much of an issue.

Although I guess things will evolve, at the time of writing many netbooks ship with 1Gb of RAM. This is okay for Photoshop CS3, but not CS4, which requires 2Gb of RAM.

Images like this are a staple of travel photography. Where the pickings are rich you can guarantee you'll take many pictures, and hence need a good system to store and backup files. The great thing today is that with diminutive netbooks you can even complete postproduction work while travelling

Online blogs

One of the most impressive things you can do is to develop your own travel blog. I recently met a very interesting couple who were literally travelling the world – taking in some of the most fantastic locations en route. Their year-long odyssey was beautifully chronicled in a blog. Their pictures were outstanding and really pulled you into their adventure. The site was neat and tidy – very professional-looking in every respect. This is something anyone can do – visit blogger.com/start to have a go yourself. In the words of Blogger, the site allows you to "share your thoughts, photos, and more with your friends and the world. It's easy to post

With small, simple cameras you can be quicker to respond to issues such as composition that can become complex with larger cameras that need a heavy-duty tripod for support. This is a major plus point – and allows me to quickly experiment and adapt to critical elements within a scene as a part of the overall composition. Travel with a full-frame DSLR or medium-format camera and this process becomes so much more difficult.

Travel can be an elective experience, as with a holiday or adventure, or it can be part of your everyday business – meeting clients, delivering work or attending conferences. This great sunset was taken while I was away at a conference with little intent to shoot landscapes. However, the convenience of my small compact digital camera made it easy to quickly catch this scene.

text, photos, and videos from the web or your mobile phone, and has unlimited flexibility to personalize your blog with themes, gadgets, and more."

If I was doing something really special I'd definitely set up a blog. Okay, so at this point, while you have no doubt heard the term 'blog' a thousand times, some of you may be wondering what it actually stands for. Well, it is a contraction of the word weblog. There is little doubt about the popularity of this form of social commentary. According to Wikipedia, in December 2007, the blog search engine Technorati tracked more than 112 million blogs. To learn more about blogging, go to http://en.wikipedia.org/wiki/Blog and then have a go yourself. Keep entries reasonably brief – around 250–300 words – and don't overload

Luggage allowances

One of the burdens of travelling with film was airport X-ray machines. I worried about the cumulative effects on even slow ISO 50 Velvia. Today, that worry is a thing of the past. SDHC and CF cards make image storage and transport hassle-free. The post-9/11 world is much more cautious than the pre-9/11 one. Allowances can be restrictive, and again this is where a good point and shoot digital compact really shines – it takes up virtually no luggage allowance (weight or space). Taken alone or as a backup for a digital SLR, it is easy to transport, even where security measures are tight.

Hand-luggage rules are applied very differently with different airlines – some are strict and some completely lax. My advice is to follow the rules for weight and size, but don't get cranky when someone blocks out your overhead space with their 3x oversized mini suitcase that has no place in the cabin. It happened to me last year. Follow the airline's rules; they are adequate for most photographers' needs.

your reader. Make sure they want to return! If you were to ask me my favourite blog, I'd have to direct you to The Travel Photographer. This blog is simply brilliant, and a must-see before travelling: go to thetravelphotographer.blogspot.com and be prepared to hang around this particularly outstanding site, run by Tewfic el-Sawy, for a while – definitely one to bookmark.

Spontaneous grab shots are made all the easier when you have a camera at hand. Here I was eating breakfast at a street café and was glued together with jam and honey. My DSLR was tucked away, but my Canon IXUS was on the table. With a few seconds to prepare, I made good use of the IXUS which turned in a great image that I panned left to right during exposure. If I'd dug around for my 'professional camera' I'd have missed the scene, not to mention got jam everywhere.

Don't miss the moment

Spontaneous pictures

Domestic animals – cats and dogs – can make interesting subjects for your camera when traveling. The two images here were largely grab shots – one catches a moggy drinking from an ornate lily tub – complete with colourful lily, and the other shows a cat napping feline ticket collector that I happened upon. This cat appeared to have achieved nirvana and everyone passing took a picture of this immensely amusing scene. Compact point and shoot cameras are ideal for this type of undemanding spontaneous photography. In both cases, these cats are clearly in some far off laid-back country and they speak volumes about life in warmer climes. Having a simple point-and-shoot camera on you at all times means you never miss this kind of opportunity.

Subject	Cat drinking from lily tub
Camera type	Canon IXUS-Series (consumer type)
Pixels (x10^6)	7.1
Focal length	7.4mm (45mm on 35mm film format)
Exposure mode	Manual*
Aperture	f/4.9
Shutter speed	1/60sec
ISO	80
Tripod	No
Flash	Yes

Additional points *Although nominally manual, in reality, on this camera, this is a fairly automated exposure mode.

Subject	Cat asleep in ticket office
Camera type	Canon IXUS-Series (consumer type)
Pixels (x10^6)	7.1
Focal length	7.3mm (44mm on 35mm film format)
Exposure mode	Manual*
Aperture	f/3.2
Shutter speed	1/60sec
ISO	80
Tripod	No, handheld
Flash	No

Additional points *Although nominally manual, in reality, on this camera, this is a fairly automated exposure mode.

Case Study 15

Symmetry

Enhance the scene

When I visit a place for the first time, I try to find a view that is both artistically composed yet embodies the soul of that place. This image of Lord Howe Island achieves both these goals – leastways in my mind. The megalithic mountain and aquamarine sea are framed between characteristic Norfolk Island pines. This arboreal sandwich provides a frame with which to view the distant sea and landscape. It has symmetry and draws the viewer into the scene. I took it with a tripod and the professional level Canon G6, a prosumer compact camera that captures both RAW and JPEG formats. This was taken in RAW mode, although I tend to shoot only JPEG on compact cameras these days, as I prefer the file quality. The opposite is true when shooting on my DSLR, where the RAW format is superior.

Compact tip

Experiment with white balance settings. I most often shoot with this set to auto, but changing this can often improve a drab shot, perhaps by switching it to the cloudy or shade setting.

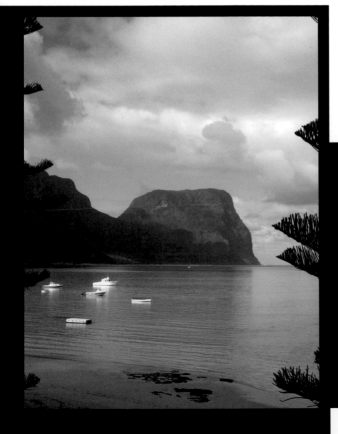

Subject	Lord Howe Island, South Pacific
Camera type	Canon G-Series Powershot (prosumer type)
Pixels (x10^6)	7.1
Focal length	Telephoto
Exposure mode	Aperture priority
ISO	50
Tripod	Yes
Flash	No
Additional points	Recorded in RAW format and later converted to a TIF file.

The panoramic print

Stitching software

This is an interesting and illuminating case study. What I'd like to do here is demonstrate how superb wall art can be produced by stitching together a panoramic picture using frames generated on a compact digital camera, and make the point that these results compare well with similar photomerges constructed using a DSLR. Although any individual compact camera frame may be limited in size, combined frames produce high resolution and hence high-quality files – even if you are using only a 5-megapixel compact camera.

There are two images here. The first shows the final stitch taken at Banteay Samre, one of the outlying temples at the World Heritage Angkor Wat site. To make this image I combined eight separate frames to yield a master file that can print to an amazing 58x12in (147x30cm).

I tried to create a major focal point in the doorway at centre, but also an interesting focal point at left to feed one into the scene and help anchor the whole panorama together. While this provides a good record shot, the second image has been manipulated, altering the feel of the picture significantly, and turning it into a serious piece of wall art. What I did was convert it into a black and white infrared image, add a sepia tone and a border. This creates a greater sense of antiquity, and helps bring out the character of this fascinating place.

I used Adobe Photoshop CS3 to accomplish the sepia transformation. The CS3 photomerge is worth a few words, as it is quite amazing technology, and rarely fails to deliver the goods.

I really like sepia images – the type of camera is largely irrelevant – a good location, keen eye and a bit of postproduction editing matters more than anything else. Quite clearly, a compact camera can do an admirable job.

Photoshop steps

1. Use Canon PhotoStitch software (or, as I did, Adobe CS3) to merge all eight frames
2. Enhance image as normal – i.e. crop, adjust levels or curves, colour channels, saturation, interpolate and sharpen. Subsequent editing produced the sepia effect
3. Use channel mixer presets to render a black and white infrared effect (red –70, green +200, blue –30)
4. Apply a sepia photofilter at 80-85 per cent
5. Duplicate layer
6. Blend using multiply at 100 per cent
7. Flatten the image
8. Use curves to lighten the image
9. Sharpen with unsharp mask (amount and radius in the 15–25 range – 20 is a good bet)
10. Add a new layer
11. Drop in border and resize border with free transform function
12. Blend using multiply at 100 per cent
13. Flatten and save (may need a further tweak in Curves)

Subject	Ta Banteay Samre, Cambodia	ISO	80
Camera type	Canon A-Series Powershot (prosumer type)	Tripod	Yes
		Flash	No
Pixels (x10⁶)	10		
Focal length	Wideangle		
Exposure mode	Stitch mode		
Aperture	Fixed at first exposure		
Shutter speed	Fixed at first exposure		

Pixels (x10^6) 10

Additional points Timing of individual frames was critical – I had to avoid people walking into the scene, but catch the whole vista before the light changed as the exposure is set with the first frame.

Content and context

Kill two birds with one stone

Many major towns around the world from Manchester to San Francisco, and Sydney to Bangkok, have a Chinatown where a uniquely Chinese microcosm adds colourful character to the surrounding prosaic modern architecture. Signage, shops and traffic provide a signature that simply begs to be photographed. I adore the frenetic madness of Chinatown.

The image here illustrates how to kill two birds with one stone. The signs and traffic say Chinatown, but to this obvious content I added subtle context; I placed a tuk-tuk in the foreground, which had a plate on its rear

clearly giving the location as Thailand. The ant-nest activity of Chinatown precludes using a tripod – I worked the scene with a simple no-thought 7-megapixel point and shoot camera – it didn't take long to fill half a 2Gb memory card. This latter point illustrates how the very strength of digital capture (lots of images at no cost) is also to a certain extent its weakness. Lots of image files require lots of editing – unfortunately, in the modern world, time is our most valuable resource, and this ability to shoot so ubiquitously impacts upon our precious free time.

Compact tip
Don't let the photo media engender a frame of mind in which you feel you need ever more megapixels. Cameras at 6-8 megapixels are simply brilliant, and are the equal of 35mm film.

Subject	Bangkok traffic
Camera type	Canon IXUS-Series (consumer type)
Pixels (x10^6)	7.1
Focal length	5.8mm (35mm on 35mm film format)
Exposure mode	Manual*
Aperture	f/2.8
Shutter speed	1/160sec
ISO	80
Tripod	No, handheld
Flash	No
Additional points	*Although nominally manual, in reality, on this camera, this is a fairly automated exposure mode.

Case Study 18

The close-up

Isolating features from their surroundings

As I ambled along a busy street while travelling overseas, I chanced upon this lovely water lily flowering in a small roadside tub. Having only a compact camera with me, I shot a few macro shots with and without flash at different settings trying to isolate the beautiful lily from its less than beautiful dusty urban context. The colours and detail in the final image provide a powerful graphic that has a lot of potential uses from editorial through to fine-art print. I feel that the quality of this image file really says something about the state of the art of today's digital cameras – bear in mind that this was taken with nothing more than a simple no frills point and shoot compact.

Subject	Water lily detail		**Shutter speed**	1/40sec
Camera type	Canon IXUS-Series (consumer type)		**ISO**	80
			Tripod	No, handheld
Pixels (x10^6)	7.1		**Flash**	No
Focal length	7.3mm (44mm on 35mm film format)		**Additional points**	*Although nominally
Exposure mode	Manual* and macro setting			manual, in reality, on this camera, this is a fairly automated exposure mode.
Aperture	f/3.2			

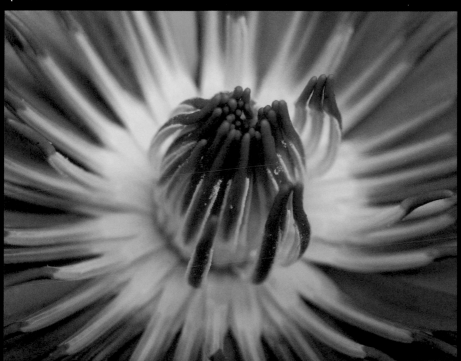

the compact camera since this genre of camera invariably
exhibits an exceptional depth of field.

Automatic flash

Dark interiors

Africa, Iraq, Cambodia and Vietnam are but four well-known regions where the latent memory of conflict remains indelibly etched upon the national conscience. Worse still, there is an omnipresent physical reminder of conflict in the form of unexploded ordnance. Landmines are a nasty legacy of the indiscriminate death and maiming that occurs during war. This image shows a few of the 20,000 landmines dug up around a single town. It may not be a picture that sells a place to prospective travellers, but it certainly paints a graphic picture of how people power and politics can poison a society and ruin the lives of countless innocent civilians.

I wasn't sure how to represent a landmine as a picture. On its own it has little impact. However, mines en masse, as in this picture, help to show the hellish scale of the problem. I took two frames – one with flash, and one with the camera mounted on a tripod, which avoided the hotspots and light fall-off that sometimes arise with flash. Never underestimate the value of a tripod – it's your most critical accessory. Despite this denigration of flash, I prefer the flash exposure on this occasion, although I needed to crop the frame slightly.

Subject	Some of the 20,000 landmines removed from around a single town	**Exposure mode**	Aperture priority
Camera type	Canon A-Series Powershot (prosumer type)	**Aperture**	f/2.8
		Shutter speed	1/60sec
		ISO	80
Pixels (x10^6)	10	**Tripod**	No
Focal length	7.3 mm (35mm on 35mm film format)	**Flash**	Yes

Case Study 20

Visualizing an image

A sense of place

When travelling I always try to find an image that evokes a sense of place – a picture that is, as they say, worth a thousand words. This scene near Bangkok's Hualamphong Railway Station sums up Bangkok – tuk-tuk, monk, pollution, signage and colourful building façade. It captures the essence of this extraordinarily busy scene. Once I spotted the monk, I saw the whole scene in my mind's eye, and this image was created before tripping the shutter, rather than simply being a piece of retrospective luck. I rattled off a few handheld shots, but a couple were less than sharp. Indeed, this was the only successful picture out of the batch.

Subject	Outside of Hualamphong Railway Station, Bangkok, Thailand		
		Exposure mode	Aperture priority
Camera type	Canon A-Series Powershot (prosumer type)	**Aperture**	f/3.2
		Shutter speed	1/640sec
Pixels (x10^6)	10	**ISO**	80
Focal length	9.6mm (46mm on 35mm film format)	**Tripod**	No
		Flash	No

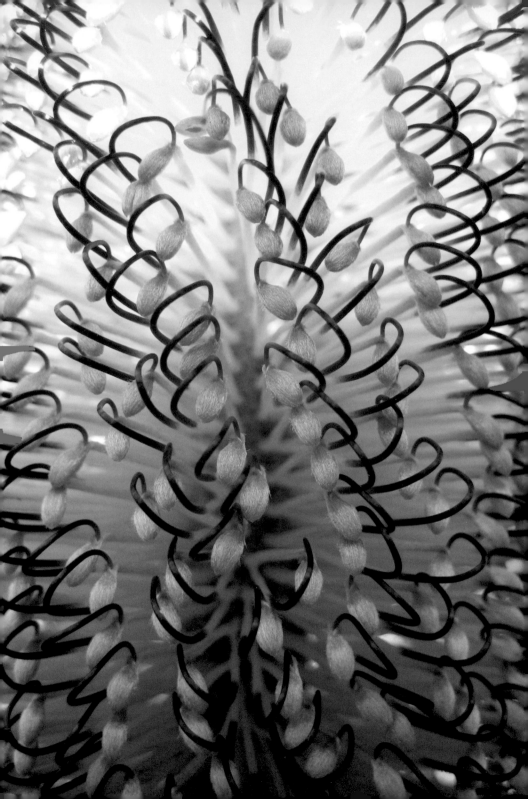

2 Nature

Introduction

Nature with your digital compact camera

By nature, I mean flora, fauna and – to a certain extent – natural environments. However, clearly one might argue that natural environments fall equally well into the landscape section of this book.

Let's begin by being clear that, for wildlife photography, nothing can compare with a DSLR and a set of good-quality lenses – 100mm macro, 70–200mm zoom, along with 300mm and/or 400mm telephotos represent a good repertoire, especially if the zoom and 300mm telephoto are fast f/2.8 lenses. This equipment is highly effective, but costly, not to mention bulky – a huge consideration when flying with today's baggage restrictions.

What I hope to show you in this section is that while a top-notch digital compact camera has clear limitations for this genre of photography, in the right hands it can still really deliver some good natural history images. As an all-in-one go anywhere package, it's quite clear compromises have had to be made in the design of digital compacts. The major one being speed of operation, it can take time to lock onto and execute an exposure. However, limited flash power and a moderate, somewhat limiting zoom range are others. Portability and an excellent macro capability offset some of the negative aspects, and many of my success stories are based on these latter attributes.

If I was to offer up the ideal subject list for this genre of camera, it would include flowers and smaller wildlife – I particularly like shooting lizards, skinks and reptiles which can all be approached (stalked) with relative ease. However, you will be amazed just how many facets of nature you can record with the average digital compact camera.

Macro photography

Capturing tiny subjects

I'd like to start this section with an example of an image file I captured on a humble Canon IXUS camera, most certainly a camera not designed for nature photography. This picture shows just what amazing results are possible today, and given the camera used – these images are clearly within the grasp of most people.

I had been hiking through some heathland near where I live. I'd reached a lookout and collapsed over the safety railing. This was not to the liking of a minute jumping spider that repeatedly charged me as I invaded his territory on this metal railing. Given that he was only half the size of my pinky fingernail, he was an extremely bold individual. The railing provided an excellent support for my Canon IXUS 7-megapixel camera. I selected the macro mode and the wideangle end of the zoom range for maximum magnification in the close-up range. I also switched off the flash, as it causes burn-out at such close range, and shot a couple of frames before my new friend began to attack the camera.

If the subject is static (as here) and you can hold the camera still enough, there is no reason why you can't get these kinds of results. A tip when shooting macro subjects like this is to select the 'centre of frame' focus option rather than any form of 'intelligent' or 'face recognition' focus option. I cropped the final frame to more or less a square as this added to the impact of the picture.

Subject	Salticid jumping spider
Camera type	Canon IXUS-Series (consumer type)
Pixels (x10^6)	7.1
Focal length	5.8mm (35mm on 35mm film format)
Exposure mode	Manual* and macro setting
Aperture	f/2.8
Shutter speed	1/250sec
ISO	80
Tripod	No, camera rested on safety railing
Flash	No
Additional points	*Although nominally manual, in reality, on this camera, this is a fairly automated exposure mode.

Compact tip

For the best quality from your digital files, shoot large fine JPEGs (or, if available, RAW mode) and convert into TIF files for postproduction enhancement and storage.

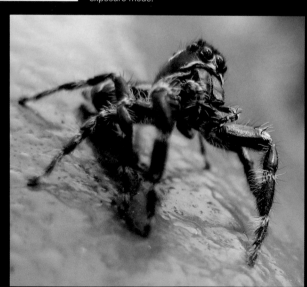

Case Study 02

Look for detail

Images with impact

Sometimes, indeed quite often, it is better to focus in on detail than to try and capture an entire animal. This was certainly the case with this silver pheasant (*Lophura nycthemera*), which I captured in close-up in order to render an image that has strong, arresting graphics.

Subject	Silver pheasant (*Lophura nycthemera*)	Shutter speed	1/30sec
Camera type	Canon IXUS-Series (consumer type)	**ISO**	80
Pixels (x10^6)	7.1	**Tripod**	No, handheld
Focal length	5.8mm (35mm on 35mm film format)	**Flash**	No
Exposure mode	Manual* and macro setting	**Additional points**	*Although nominally manual, in reality, on this camera, this is a fairly automated exposure mode.
Aperture	f/2.8		

Background decisions

Isolate or give context

I really enjoy macro photography. On these pages are two images of a northern forest crested lizard, and two of a forest crested lizard – all shot in close-up, but achieving different goals.

1 Forest crested lizard eating a hawk moth caterpillar. This image shows behaviour. I set macro and zoomed out to the telephoto range of the lens. At this working distance it is possible to use the built-in flash for illumination without burn-out. This was essential as the depths of a rainforest are very gloomy and dark – no one could handhold their camera in the ambient light.
2 Northern forest crested lizard. I found this beautiful specimen near the hotel I was staying in. I shot him using the wideangle end of my

Subject	Forest crested lizard eating a hawk moth caterpillar
Camera type	Canon IXUS-Series (consumer type)
Pixels (x10^6)	7.1
Focal length	17.4mm (105mm on 35mm film format)
Exposure mode	Manual* and macro setting
Aperture	f/14
Shutter speed	1/60sec
ISO	80
Tripod	No
Flash	Yes

Subject	Northern forest crested lizard (*Calotes emma alticristatus*)
Camera type	Canon A-Series Powershot (prosumer type)
Pixels (x10^6)	10
Focal length	7.3mm (35mm on 35mm film format)
Exposure mode	Aperture priority
Aperture	f/3.5
Shutter speed	1/60sec
ISO	80
Tripod	No, handheld
Flash	No

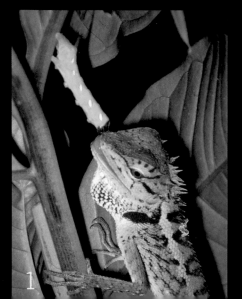

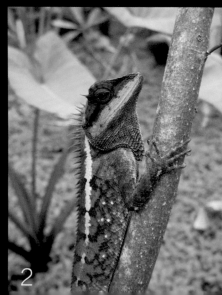

zoom with the macro facility on. This is a 10-megapixel file from my Canon Powershot camera, and so can take a little cropping to enhance its composition. As the lizard was in the open, I did not need to rely on artificial light – the background is not distracting and enhances the overall image, providing a bit of context.

3 Northern forest crested lizard. The sole illumination for this image is artificial flashlight – and as flash output is low, and since light falls off rapidly according to the inverse square law, the animal is isolated against an inky black backdrop. I quite like this effect, which is good for editorial use where it has oomph and can easily accommodate bright drop-in text.

4 Forest crested lizard shot as a portrait to illustrate both its splendour and detail, and also the amazing sharpness and quality some compact cameras are capable of rendering.

The point I'm making with these four images is that you can still control the final appearance of the image with a compact camera in the same way that you can with a DSLR. You just have to be aware of the strategies open to you, and know how and when to apply them.

Subject	Northern forest crested lizard (*Calotes emma alticristatus*) illuminated solely with flash
Camera type	Canon IXUS-Series (consumer type)
Pixels (x10^6)	7.1
Focal length	17.4mm (105mm on 35mm film format)
Exposure mode	Manual* and macro setting
Aperture	f/14
Shutter speed	1/60sec
ISO	80
Tripod	No, handheld
Flash	Yes

Subject	Forest crested lizard (*Calotes emma emma*)
Camera type	Canon A-Series Powershot (prosumer type)
Pixels (x10^6)	10
Focal length	29.2mm (140mm on 35mm film format)
Exposure mode	Aperture priority
Aperture	f/4.1
Shutter speed	1/60sec
ISO	80
Tripod	No, handheld
Flash	Yes

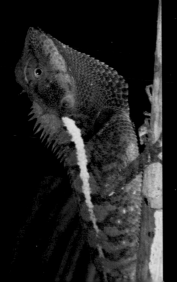

3

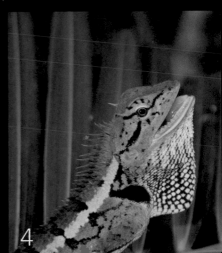

4

Content and context

Wildlife portraits

When I tell people this picture was taken with nothing more than a 5-megapixel compact camera they can't believe it. I was visiting a Buddhist temple on an oppressively hot and humid tropical day. Despite this, I completed an ascent of the temple perched high on top of a giant limestone karst. The ascent took about an hour and when I'd finished I was dripping wet. Still, despite this, 50 feet from the bottom I came across this suckling long-tailed macaque (*Macaca fascicularis*).

I was so bedraggled I didn't feel like taking any pictures. Still, I shot a handful of grab shots. I shot at the telephoto end of the zoom range and employed flash to isolate the subject, freeze motion and enhance colour. If any picture in this book shows the virtue of this camera genre, this has to be it. It is sharp, vibrant, evocative and could almost have been shot in a studio, such is the lighting. Sadly, the unwarranted prejudice against image files below 6 megapixels means this image has limited commercial value – although I have no idea why, when with interpolation this image will produce a good-sized print.

Compact tip

When you buy your computer, keep sufficient money to add extra RAM. 1Gb is the minimum with XP (more is required with Vista), and buy a good image-editing program like Photoshop Elements.

Subject	Long-tailed macaque (*Macaca fascicularis*)
Camera type	Canon A-Series Powershot (prosumer type)
Pixels (x10^6)	5
Focal length	29.2mm (140mm on 35mm film format)
Exposure mode	Aperture priority
Aperture	f/4.5
Shutter speed	1/60sec
ISO	50
Tripod	No
Flash	Yes

Case Study 05 Change your position

An insect's eye view

Leafy purple flag (*Patersonia glabrata*) is not uncommon where I live, but nonetheless it still fascinates me as its vivid blue petals are so delicate and its exquisite yellow reproductive structures so perfectly colour co-ordinated with the azure petals.

I thought it would be an interesting exercise to get low down and take an insect's eye view of this photogenic flower. I used a 5-megapixel Canon Powershot to catch this macro perspective. The great thing about compact camera lenses is their short focal lengths (compared with 35mm film cameras) which arise from the diminutive sensors used in these cameras (see page 112). The short focal lengths provide a much greater depth of field and in macro this is a real advantage, providing the feeling of greater overall sharpness.

Subject	Leafy purple flag	Exposure mode	Manual* and macro setting
	(*Patersonia glabrata*)	Aperture	f/3.2
Camera type	Canon A-Series Powershot	Shutter speed	1/40sec
	(prosumer type)	ISO	80
Pixels (x10^6)	7.1	Tripod	No, handheld, with elbows and
Focal length	7.3mm (44mm on 35mm		forearms braced against a rock
	film format)	Flash	No

Lead-in lines

There are so many options for using lead-in lines. One case study in this book uses a receding row of stone statues. Here I use a dry stone wall to lead the viewer into the frame. It directs the viewer from the outside of the frame into the depths of the scene

This is a useful technique to help viewers engage with the vista and provides a greater sense of the third dimension. I have this image as a very large print on my bedroom wall – the depth of the 5ft (1.5m) print seems to open the room out as it it leads into the Yorkshire Dales themselves.

Reveal character

Focus sharply on the eyes

I was keen to put together a portfolio of work that really got under the skin of Thailand's rainforests. Some of this work has been published, some ended up as a Flash slideshow on my website (marklucock.com). However, it wasn't until a subsequent visit to these magnificent rainforests that I actually managed to shoot the iconic lead player in these tropical woodlands – the white-handed gibbon (*Hylobates lar*). I feel that any primate image is always best when attention is given to the face and to the character etched into it. So this image isolates the face of what is, by virtue of its haunting wail, the undisputed lead character within the ongoing saga of rainforest life. A tip with any wildlife photography, be it of insects or primates – ensure the eyes are in focus – this is a cardinal rule. Who could not doubt that the endearing eyes of this gibbon are not pathways to its soul?

As you can see, this image has been cropped to a square to enhance the perspective of this gibbon's face. However, cropping is also a useful tool for removing extraneous detail. The beauty of digital files over transparencies or negatives is that cropping is easy (and doesn't involve a pair of scissors), although obviously once a transparency or negative is scanned it's easy to crop it down to improve its perspective.

Subject	White-handed gibbon (*Hylobates lar*)
Camera type	Canon IXUS-Series (consumer type)
Pixels (x10^6)	7.1
Focal length	17.4mm (105mm on 35mm film format)
Exposure mode	Manual*
Aperture	f/4.9
Shutter speed	1/60sec
ISO	80
Tripod	No, handheld
Flash	Yes
Additional points	*Although nominally manual, in reality, on this camera, this is a fairly automated exposure mode.

Compact tip

A cardinal rule when using image-editing software is not to overdo sharpening and saturation. Either of these can ruin a good picture.

Case Study 07

Best practice

Take your time

The advent and subsequent evolution of commercially viable digital cameras has been rapid – a chronology that spans but a few years. With that in mind, this image represents a piece of history as it was taken on a 3.2 megapixel Sony Cybershot. By today's standards 3.2 megapixels seems archaic. However, results like the image shown here are quite adequate for editorial use and home printing providing you don't try and print too large. A5 should be fine. Despite few pixels, I still applied rigorous methodology in executing this image. I used a tripod and took a lot of time composing the scene. The young bracken frond at centre provides key foreground interest to the receding carpet of bluebells. This image depicts an idyllic scene that to many of us represents a familiar harbinger of warmer weather – the annual spring flowering of the British bluebells.

While I wouldn't use a 3.2-megapixel camera today, I do still use a 5-megapixel one, and consider this adequate for most purposes except large, commercially viable prints.

Subject	Carpet of bluebells, Yorkshire, UK
Camera type	Sony Cybershot P72
Pixels (x10^6)	3.2
Focal length	6mm
Exposure mode	Manual
Aperture	f/2.8
Shutter speed	1/30sec
ISO	160
Tripod	Yes
Flash	No
Additional points	The camera was focused on the fern as the predominant element in this scene, then the frame was recomposed to harmoniously blend all the visual elements.

Isolate the subject

Move in close

I've always been drawn to heathland. In the UK I enjoyed exploring the heather and gorse, watching the graylings and blue butterflies dance above the flowers and discovering secretive adders sunbathing in the summer sun. In Australia the heathland has a similar character, but is more extensive and has a far more diverse flora and fauna to explore. Spider flowers are a signature species of the colourful and unusual flora that can be found on the heathland bedecked plateaux around Sydney.

This heathland may not quite match the Kwongon of southwest Australia or South Africa's Fynbos, but it is nonetheless absolutely magnificent and, apart from the aforementioned areas, no heathland in the world can touch it. To shoot the spider flower species shown here I got in close and concentrated on maintaining

Subject	Fuschia (*Epacris longiflora*)
Camera type	Canon A-Series Powershot (prosumer type)
Pixels (x10^6)	5
Focal length	7.3mm (35mm on 35mm film format)
Exposure mode	Aperture priority and macro
Aperture	f/5.0
Shutter speed	1/60sec
ISO	50
Tripod	No
Flash	Yes

Subject	Red spider flower (*Grevillea speciosa*)
Camera type	Canon IXUS-Series (consumer type)
Pixels (x10^6)	7.1
Focal length	7.3mm (35mm on 35mm film format)
Exposure mode	Manual* and macro setting
Aperture	f/2.8
Shutter speed	1/500sec
ISO	80
Tripod	No
Flash	No

Additional points *Although nominally manual, in reality, on this camera, this is a fairly automated exposure mode.

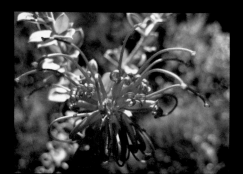

sharpness across the field of view and ensuring that the composition isolated the flower, yet kept it recognizable to viewers.

Some floral subjects are so photogenic it would, in all likelihood, be difficult to mess up a photograph of them, even for someone new to the craft. The Christmas bells shown here are a case in point. The flower is so vividly coloured and unusual in its form that, providing the camera is held still enough, it would be difficult to not get a first-rate image.

Subject	Christmas bell (*Blandfordia nobilis*)
Camera type	Canon IXUS-Series (consumer type)
Pixels (x10^6)	7.1
Focal length	5.8mm (35mm on 35mm film format)
Exposure mode	Manual* and macro setting
Aperture	f/2.8
Shutter speed	1/320sec
ISO	80
Tripod	No
Flash	No
Additional points	*Although nominally manual, in reality, on this camera, this is a fairly automated exposure mode.

Subject	Flannel flower (*Actinotus helianthi*)
Camera type	Canon G-Series Powershot (prosumer type)
Pixels (x10^6)	7.1
Focal length	28.8mm (140mm on 35mm film format)
Exposure mode	Aperture priority and macro
Aperture	f/4.0
Shutter speed	1/125sec
ISO	50
Tripod	No, handheld
Flash	No

Low-light environments

Use a compact tripod

My favourite photographic subjects are intimate scenes of verdant woodland, particularly the rainforest. I'm always in awe of the massive trees, and more so their gigantic buttress roots. The gloomy light in rainforests means you can't do without a tripod. I shot this tree using the two-second delay on my 5-megapixel Canon Powershot set to aperture priority, a low ISO and the flash switched off. A small, light tripod with a quick-release platform and compact camera are a real blessing in hot, humid environments where any extra weight makes a huge difference in terms of comfort and mobility.

This rainforest tree is particularly unusual – and hence photogenic – given the huge stabilizing fins that embellished its girth. It's a real photographic gem that conjures up evocative thoughts of jungle living.

Compact tip

When travelling, ensure you have the appropriate travel adapters to keep your batteries charged. Digital photography needs power not just for the camera, but for portable storage devices as well.

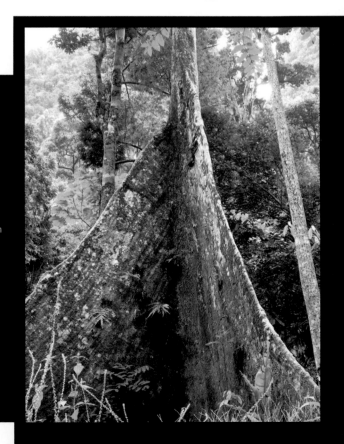

Subject	Rainforest giant with huge buttress roots
Camera type	Canon A-Series Powershot (prosumer type)
Pixels (x10^6)	5
Focal length	7.3mm (35mm on 35mm film format)
Exposure mode	Aperture priority
Aperture	f/5.6
Shutter speed	One second
ISO	50
Tripod	Yes
Flash	No
Additional points	I used a two-second time delay to avoid camera shake when depressing the shutter.

Case Study 10

Garden wildlife

Shoot what's on your doorstep

My garden is home to myriad wildlife – some elusive, others more secretive. The minute delicate garden skinks that ply through the grass and leaf litter with consummate ease are among the most ubiquitous of all my outdoor tenants. While they are easily found, it takes patience and stealth to get close enough to one to execute a good portrait shot like this.

Subject	Delicate garden skink
Camera type	Canon A-Series Powershot (prosumer type)
Pixels (x10^6)	10
Focal length	7.3mm (35mm on 35mm film format)
Exposure mode	Aperture priority and macro setting
Aperture	f/2.8
Shutter speed	1/400sec
ISO	80
Tripod	No
Flash	No
Additional points	At 1cm from the subject, care is needed in not damaging the front lens element, or indeed knocking into the subject itself.

I used a 10-megapixel Canon Powershot camera set to macro focus and the wideangle end of my zoom allowing me to get 1cm from the skink. The flash cannot be used at this distance and was switched off. At ISO 80 the image is razor sharp and you need to magnify the file quite significantly before any level of pixelation occurs. To ensure critical focus I made sure centre-frame focusing was active. The reason macro shots like this work, leastways in part, is that they allow people to explore something that they would never normally see in everyday life – as here, where something 4cm long takes on the apparent proportions of a gargantuan Jurassic dinosaur. The downside of shooting macro is that, at 1cm, it is all too easy to bump, indeed scratch, the front element of the lens, or as I always seem to do, get a liberal dusting of pollen all over the lens – still, when this kind of image making works, it works very well indeed.

Compact tip
When resizing a digital compact camera image in Photoshop use bicubic smoother to enlarge and bicubic sharper to reduce it.

Image editing

The image-editing program that will best suit you depends on so many factors. How confident are you with computers and different levels of software? What do you want to do with your images at the end of the day? Are you using your compact camera as a raw amateur, a keen amateur, or a professional photographer? Perhaps, like me, you also use a digital SLR, but recognize how valuable a compact camera can be, even to a professional workflow.

Whatever level of expertise you possess, there is an image-editing program to suit you – some are simple and cheap, some complex and fairly expensive. I can recommend the following programs: Adobe Photoshop Elements for reasonably priced, but high-quality still image editing (around £60/US$100). Extra utility has been added to the Adobe Photoshop Elements and Premiere Elements Software Bundle, which provides a user-friendly image- and video-editing application combo (around £90/US$150). Another economically priced option is Corel Paint Shop Pro Photo which can render very professional output.

Of course at the pinnacle of image editing is the fully specified professional program – Adobe Photoshop CS4, which is substantially more expensive than the former programs, but is hard to beat for digital image editing, leastways in my opinion.

A simpler program for novices (and the more experienced) is Adobe Lightroom, asset management software that fits the same niche as Aperture, a program designed for Mac users. This is a great program for organizing (managing) and editing your image collection.

I particularly like the ability of this program to render flash-based image galleries that can be used on digital projectors for slide shows or for uploading to your website – very polished results are possible with this program.

The user interface you see with Adobe Photoshop CS4, the present industry standard for image editing.

Other programs also exist – I've mentioned but a few here. There are also some excellent guide books available on how to use this software (some bad ones too – in my view the poor ones outnumber the good ones). I'd like to mention one author who writes superb books that really open up the possibilities inherent in image-editing programs – Scott Kelby. He has written books on Photoshop and Lightroom, and I'd recommend these to anyone, whether new to the subject, or more seasoned.

Personally, for editing images I use Photoshop CS3 and, for managing my files and key wording, I actually prefer Adobe Bridge, a program that works closely with Photoshop.

Mantid

I spotted this small mantid in my garden while mowing the lawn. The original image is untouched – it's straight out of the camera. It was taken handheld on a 7-megapixel Canon IXUS camera. I then opened the original in Adobe Photoshop and performed the following to improve the image:

- Assign profile (optional depending on intended use): Edit> Assign Profile> Adobe 1998.

The user interface you see with Adobe Lightroom, an asset management program that is ideal for beginners and keen amateurs.

- The mantid is a little bit small, so I cropped the frame: Tool Bar> Crop Tool> Crop.
- If you want to print an image, you need to have it at the appropriate resolution and size – in this case I interpolated the image to create a slightly larger file: Image> Image Size (Set resolution to 300dpi, dimension to whatever you require; 8x10in in this case, and select bicubic smoother).
- Tweak the image density: Image> Adjustment> Levels (I needed to move the cursor slightly to the left). When you get the hang of Levels, play with the Curves tool, which gives greater control over this process.
- Tweak the colours: Image> Adjustment> Colour Balance (I added a couple of units of red in the mid-tones and highlights).
- Tweak the saturation: Image> Adjustment> Hue/Saturation (I added seven units of saturation).
- Set the image to 100 per cent magnification and sharpen: Filter>Unsharp Mask (No advice here – the recipe depends on image size and quality – for this image I used amount = 150, radius = 0.6, threshold = 0,

but most of my images are larger than this and an amount up to 300 and radius of up to 1 are typical).
- Save as either a JPEG or TIF, depending on need.

Beach

The original Canon G6 (7 megapixel) image of this beach is complete with some foreground interest, but is flat and washed out in terms of colour. To inject some pizzazz, I opened the file in Adobe Photoshop and performed the following tasks:
- Assign profile (optional depending on intended use): Edit> Assign Profile> Adobe 1998.
- Interpolate the image to create a slightly larger file: Image> Image Size (Set resolution to 300dpi, dimensions to 9x12in, and select bicubic smoother).
- Tweak the image density: Image> Adjustment> Curves (The effect I used was very slight).

Before

After

- Tweak the colours: Image> Adjustment> Colour Balance (I added seven units of red in the mid-tones and highlights).
- Tweak the saturation: Image> Adjustment >Hue/Saturation (I added 20 units of saturation because the original was so pasty).
- Set the image to 100 per cent magnification and sharpen: Filter> Unsharp Mask (No advice here – the recipe depends on image size and quality, so experiment).
- Save as either a JPEG or TIF, depending on need.

Spider

This St Andrew's Cross Spider had woven its web across my patio doors, so before I evicted her, I took an image with my 7-megapixel Canon IXUS compact. The original file isn't really a keeper, but was improved with a bit of work in Photoshop:

- Assign profile (optional depending on intended use): Edit> Assign Profile> Adobe 1998.

- The spider is a little bit small, so I cropped the frame: Tool Bar> Crop Tool> Crop.
- I interpolated the image to create a slightly larger file: Image> Image Size (set resolution to 300dpi, dimension to whatever you require (8x8in in this case), and select bicubic smoother).
- Tweak the colours: Image> Adjustment> Colour Balance (I added seven units of red in the mid-tones and highlights).
- Tweak the saturation: Image> Adjustment> Hue/Saturation (I added 19 units of saturation – I don't advise this much usually on compact camera files, but for this subject it seemed okay).
- Set the image to 100 per cent magnification and sharpen: Filter >Unsharp Mask.
- Save as either a JPEG or TIF, depending on need.

Before

After

Pattern

Explore your subject

Good photographers are, on the whole, opportunists – looking for seminal images wherever they go. So it should come as no surprise that when I came across this pet macaw in a dingy, out of the way back street, I thought this highly coloured pet would make a good subject for my camera. Not all good wildlife photos are necessarily 'wild'. The fantastic colours and graphic pattern of this captive macaw's livery were my target. Boy, what a time I had here. This macaw was mean – he really didn't like having his picture taken, and even threw his water over me in disgust. I suspect he had a serious personality disorder! The final image here is a crop that I abstracted and tweaked in Photoshop to augment colours.

A beautiful reminder of a less than beautiful bird – leastways personality-wise. I should add that I dislike, indeed detest, seeing any animals in captivity and exotic birds are no exception – be they budgerigars or macaws. The fact that parrots are quite astounding in their intelligence makes it even more distressing to see them 'banged up'.

These thoughts notwithstanding, captive animals do make a good place to begin honing your photography skills, and so faced with an opportunity such as this, I see no reason not to take a handful of pictures. Given the psychotic nature of this macaw I zoomed out to the telephoto setting of my lens and used flash to freeze its movements.

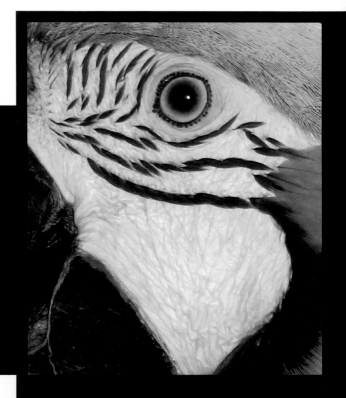

Subject	Macaw
Camera type	Canon A-Series Powershot (prosumer type)
Pixels (x10^6)	10
Focal length	21.7mm (104mm on 35mm film format)
Exposure mode	Aperture priority
Aperture	f/3.5
Shutter speed	1/60sec
ISO	80
Tripod	No
Flash	Yes

Case Study 12 # High key

Work with exposure

Shooting non-human primates is a bit like shooting people, except they can be considerably more expressive. I spent time shooting a troupe of macaques that had intercepted tourists heavily weighed down with a good supply of food. I subtly worked around the troupe, looking for good portraits. This was taken on a 5-megapixel Canon Powershot camera, and is very high key – that is leaning towards overexposure – it works well on this character, and is partly down to good ambient light levels, particularly in the background, which exceed that needed to expose the macaque's face which is itself in dimmer light. Perfectly balanced flashlight is what actually illuminates the face. One of the great things about the Canon Powershot series I use is the ability to quickly dial in up to + or – 2 stops of exposure and/or + or – 2 stops of flash illumination, giving ultimate control in picture making.

Compact tip
The one thing digital excels at is low-light and dusk photography. It was always a bit hit and miss when using film due to reciprocity failure. Digital removes this problem and produces a better tonal range in evening and twilight shots.

Subject	Long-tailed macaque (*Macaca fascicularis*)
Camera type	Canon A-Series Powershot (prosumer type)
Pixels (x10^6)	5
Focal length	29.2mm (140mm on 35mm film format)
Exposure mode	Aperture priority
Aperture	f/5.6
Shutter speed	1/60sec
ISO	50
Tripod	No
Flash	Yes

The stealthy approach

Stalking a subject

The exclusion (or approach) zone of lizards varies according to the size of the animal. If you use stealth to approach small lizards, it is quite possible to get within a few inches. This means you can shoot in macro mode, which seems to produce particularly sharp image files. If you are shooting larger reptile fauna, then you may be lucky to get to within 6 to 10ft (1.8 to 3 metres), and so you need to employ the maximum telephoto setting of your camera's zoom lens. No doubt the latest generation of image-stabilized lenses found on compact cameras are a boon in obtaining sharp images in this type of photography. If light levels are high, you may not need to employ

flash, but flash can still be useful as it helps freeze motion and bring out colours. The two images here show reptiles at either end of the extreme – a diminutive northern forest crested lizard shot close up using the macro setting of a 10-megapixel Canon Powershot and an eastern water dragon shot from a distance using the telephoto end of a 5-megapixel Canon Powershot camera. Both images succeed, but I prefer the image characteristics when shooting macro.

Compare the 5-megapixel image of the eastern water dragon (below left) with the same species shot on a professional-level DSLR (below right). The DSLR image has the edge, but with a 70–200mm zoom, grip and flashgun, it's heavy

Subject	Northern forest crested lizard (*Calotes emma alticristatus*)
Camera type	Canon A-Series Powershot (prosumer type)
Pixels (x10^6)	10
Focal length	29.2mm (140mm on 35mm film format)
Exposure mode	Aperture priority and macro
Aperture	f/4.1
Shutter speed	1/60sec
ISO	80
Tripod	No
Flash	Yes

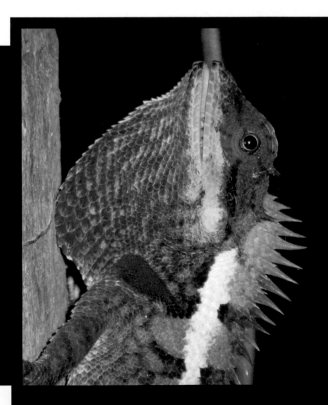

kit to carry. The compact camera picture is adequate, and was no effort to carry on the very long, very hot walk during which this picture was taken – I dare not think about the effort that carrying my DSLR kit would have entailed.

Compact tip

Carry a notebook and pen in your camera bag to scribble down thoughts that might help in future photographic endeavours – don't bother with exposure information, though, as this EXIF is already tagged to the image file as metadata. You may need to note the length of any long exposures though.

Subject	Eastern water dragon (*Physignathus lesuerii lesuerii*)
Camera type	Canon A-Series Powershot (prosumer type)
Pixels (x10^6)	5
Focal length	23.4mm (112mm on 35mm film format)
Exposure mode	Aperture priority
Aperture	f/8
Shutter speed	1/60sec
ISO	50
Tripod	No
Flash	Yes

Subject	Eastern water dragon (*Physignathus lesuerii lesuerii*)
Camera type	Canon DSLR
Pixels (x10^6)	8
Focal length	200mm
Exposure mode	Manual
Aperture	f/8
Shutter speed	1/90sec
ISO	100
Tripod	No
Flash	Yes

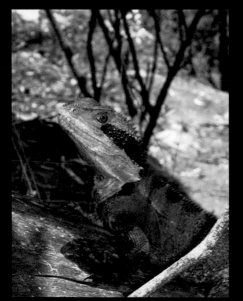

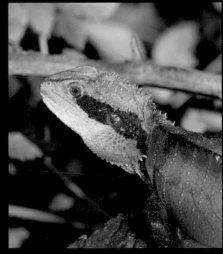

Using stitch mode

In-camera panoramics

You should never underestimate the tremendous potential of a compact digital camera. This extreme panoramic image of a strangler fig growing in sub-tropical rainforest was created by stitching together a number of individual frames exposed on a 5-megapixel Canon G5 compact camera. I used a good quality pan and tilt tripod head with a built-in spirit level to ensure the camera would spin horizontally without any shift in the vertical alignment that must remain at 90 degrees to the horizon. The camera was placed in stitch mode and the exposures made – these should overlap by around a third of a frame to ensure accurate registration of the repeat detail in each exposure. The final stitch was assembled in the camera's proprietary stitching software and finalized in Adobe Photoshop which was used to enhance colours slightly, interpolate and sharpen the image.

Panoramas are a popular photographic format that can encompass a moderate, say a 2:1 ratio, right through to a 360-degree sweep. Stitching can be a bit hit and miss, and is sometimes extremely problematic, such as with moving subjects – particularly, for instance, seascapes with breaking waves. But when they work, little can compare with a well-thought-out and executed panoramic stitch. When a camera is used in stitch mode, all exposures and white balance are set at the first frame and remain constant for all subsequent exposures.

Compact tip

Don't be a pixel peeper! Judge the worth of a camera by the maximum size you can print to and still retain the highest quality in colour and sharpness. Ascertain this after using a high-quality interpolation software package. It should be around 15x20in (38x50cm) for a 10-megapixel compact camera.

Subject	Strangler fig – subtropical rainforest
Camera type	Canon G-Series Powershot (prosumer type)
Pixels (x10^6)	5
Focal length	Wideangle
Exposure mode	Stitch
Aperture	Unrecorded
Shutter speed	Unrecorded
ISO	50
Tripod	Yes
Flash	No
Additional points	A spirit level with pan and tilt tripod head were used

with attention to retain a constant horizon angle.

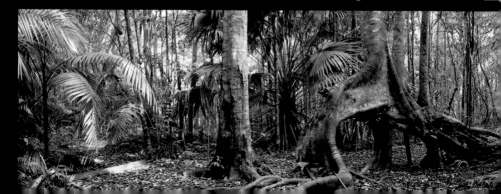

Case Study 15

Be prepared

Carry your camera at all times

When out walking in the countryside you never quite know what you might come across. With the diminutive size of modern digital compacts there is little excuse not to have a camera with you at all times and so you should never miss being able to record any plants or animals you encounter. A regular walk I do is at the back of my house, but this bushland involves much climbing and in high temperatures I don't always want to be weighed down with a DSLR and associated paraphernalia. So I now always take my Canon IXUS with me. It is excellent for shooting plants and, as you can see here, turns in a respectable job of larger fauna. This lace monitor, typically, exited the scene vertically up the nearest tree. He moved out of arm's reach, but within the reach of my camera. I shot several frames – none are stellar, but they are reasonable images of one of Australia's largest reptiles.

Compact tip

The postproduction image enhancements that all nature and landscape photographers need to be aware of are: levels, crop, healing brush, clone stamp tool, colour balance, hue/saturation and sharpen.

Subject	Lace monitor (*Varanus varius*)
Camera type	Canon IXUS-Series (consumer type)
Pixels (x10^6)	7.1
Focal length	17.4mm (105mm on 35mm film format)
Exposure Mode	Manual*
Aperture	f/4.9
Shutter speed	1/160sec
ISO	80
Tripod	No
Flash	Yes
Additional points	*Although nominally manual, in reality, on this camera, this is a fairly automated exposure mode.

Don't forget auto

Geometry in nature

Nature is omnipotent, with life abounding in the most improbable places. I was walking along a quiet sandy beach when I came across these geometric patterns in the wet sand – an artefact of secretive shoreline fauna. The patterns were perfect in order and design, and to produce them oneself would require careful orchestration with compass and protractor. A point and shoot compact on auto is ideal for recording this kind of image.

Modern cameras are so much better at hitting the exposure just right. A few years ago shooting on a bright beach like this would have guaranteed underexposure. This is a rare thing these days – and when it does occur it's easily corrected in postproduction.

Compact tip

If you are shooting wildlife and don't want to be loaded down with a tripod, which can be limiting with this subject/camera combination, use TTL fill flash to add pizzazz to your image and also to freeze motion. It works well in macro photography at the telephoto end of the zoom lens in particular.

Subject	Geometric sand patterns caused by marine fauna
Camera type	Canon IXUS-Series (consumer type)
Pixels (x10^6)	7.1
Focal length	5.8mm (35mm on 35mm film format)
Exposure mode	Manual*
Aperture	f/8
Shutter speed	1/250sec
ISO	80
Tripod	No
Flash	No
Additional points	*Although nominally manual, in reality, on this camera, this is a fairly automated exposure mode.

Case Study 17

Use your tripod

Even in good light

Nature can be sympathetic to photographers. This gateway (Gopura) has been totally enveloped by a huge tree, making it hugely evocative and photogenic. Since people kept appearing through the gateway I set my camera up on a tripod so as to retain the best composition and took bracketed shots of varying settings whenever I had a people-free view. It's hard to mess up a shot like this, but I felt that the 45-degree angle from frontal perpendicular worked best, especially when shot from a fairly low viewpoint.

It was a fun session in which I engaged a young girl selling postcards in conversation – she was with her young brother and they were picking nits (head lice) from one another's hair! This was a great social gathering – I struck up conversations with other photographers and even learned some new Photoshop tricks! This is one of those images that could slip into any of the sections in this book – it is a travel shot and equally it is a landscape, but I feel primarily it is a nature shot, as without the natural element of the tree, there is simply no picture here worth taking.

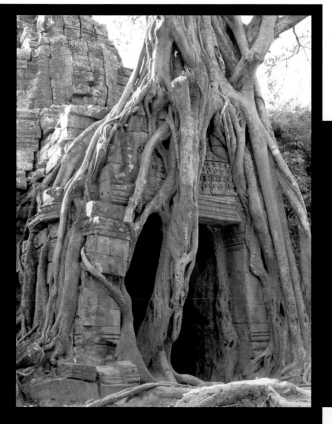

Subject	East Gopura, Ta Som, Cambodia
Camera type	Canon A-Series Powershot (prosumer type)
Pixels (x10^6)	10
Focal length	10.8mm (52mm on 35mm film format)
Exposure mode	Aperture priority
Aperture	f/4
Shutter speed	1/25sec
ISO	80
Tripod	Yes
Flash	No

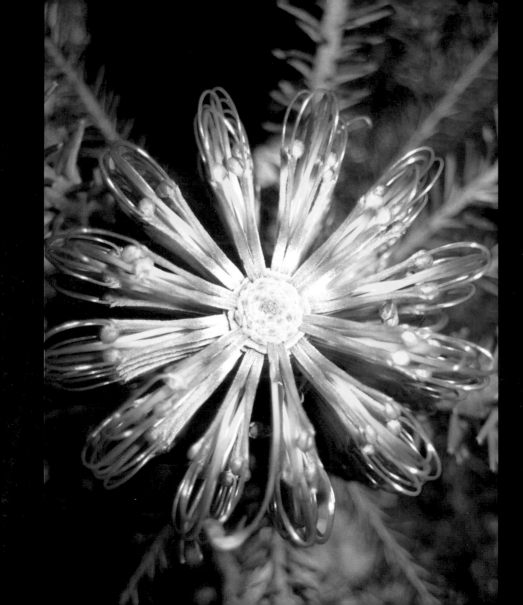

Photography masterclass
Isolating graphic pattern

The secret in macro photography of animals is to ensure the eyes are always in focus. If shooting plants, why not try to catch a graphic pattern? The image here was taken on a humble Canon IXUS, but has rendered a superbly interesting graphic of this fascinating flower.

The secret is to recognize the importance of symmetry, the need to exclude any extraneous information that breaks symmetry (i.e. erroneous leaves), and the importance of a flat and accurate plane of focus.

Improve perspective

Cropping in postproduction

This abstraction shows a fast-flowing river and convoluted tree roots – in my view it has a certain fine-art quality that more than justified its capture. The light was already very dim and I closed the aperture up which, given the low ambient light, gave a fairly long shutter speed – enough to blur the water movement. As a generic arty shot of the natural world, I think this picture works quite well – and has merit.

The image has had a subtle cosmetic crop applied to emphasize the key features; focusing the viewers' attention on the water and roots.

Compact tip

Think about your likely workflow and hardware needs in advance. It's better to plan out a system, rather than develop one that can't cope with your long-term needs. Buy a hard disk big enough to accommodate your future needs, and adopt a back-up system using DVDs.

Subject	Tree roots embracing rock in upland stream	**ISO**	80
Camera type	Canon A-Series Powershot (prosumer type)	**Tripod**	Yes
		Flash	No
Pixels (x10^6)	10	**Additional points**	The roots embracing this rock
Focal length	7.8mm (37mm on 35mm film format)	follow the anatomic pattern of veins and arteries	
Exposure mode	Aperture priority	that course blood through our bodies.	
Aperture	f/7.1	As I took this frame, I thought how my arms often	
Shutter speed	One second	look like this after dragging a tripod and camera around all day.	

Case Study 19

Injecting light

Shooting in dark environments

Rainforests are busy places with nutrients in the form of leaf litter being recycled very quickly and efficiently. This image shows one of nature's high-tech recyclers, a very large millipede – one of many plying their trade between two buttress roots. Invertebrates (perhaps because they are so bizarre) fascinate me more than any other biological subject, yet the size and number of these creatures still manages to make my skin crawl a bit. I took several shots of these creatures on a 5-megapixel Canon Powershot camera, but only caught two or three good images. It is most probably the 'ugh' factor, leastways to a certain extent, that makes this image work. I used both flash and macro to catch this detail.

If you don't have a tripod, or it's inconvenient to use one, try buffering your camera against a convenient support using a crumpled handkerchief. This might be a damp buttress root as here or it could be a dusty or rough brick wall. In either event the hanky will protect your camera and help orient it for the best composition. An articulated LCD screen is also really useful as an aid in stabilizing your camera – I find it far easier to hold such cameras steady than those with a fixed rear LCD screen.

Subject	Rainforest millipedes		**Aperture**	f/6.3
Camera type	Canon A-Series Powershot		**Shutter speed**	1/60sec
	(prosumer type)		**ISO**	50
Pixels (x10^6)	5		**Tripod**	No
Focal length	7.3mm (35mm on 35mm film format)		**Flash**	Yes
Exposure mode	Aperture priority and macro			

Macro magic

Bring out intricate detail

It is always a pleasant and unexpected surprise to come across orchids. They are usually found in isolation, meshed into some unkempt and unremarkable vegetation and so frequently overlooked. Three of the species here were spotted near my house, but in all cases could easily have been missed from a distance. The three wild species here – copper beard,

Subject	Copper beard orchid (*Calochilus campestris*)
Camera type	Canon IXUS-Series (consumer type)
Pixels (x10^6)	7.1
Focal length	5.8mm (35mm on 35mm film format)
Exposure mode	Manual* and macro setting
Aperture	f/8
Shutter speed	1/100sec
ISO	80
Tripod	No
Flash	No
Additional points	*Although nominally manual, in reality, on this camera, this is a fairly automated exposure mode.

Subject	Tartan-tongue orchid (*Cryptostylis erecta*)
Camera type	Canon IXUS-Series (consumer type)
Pixels (x10^6)	7.1
Focal length	5.8mm (35mm on 35mm film format)
Exposure mode	Manual* and macro setting
Aperture	f/2.8
Shutter speed	1/100sec
ISO	80
Tripod	No
Flash	No
Additional points	*Although nominally manual, in reality, on this camera, this is a fairly automated exposure mode.

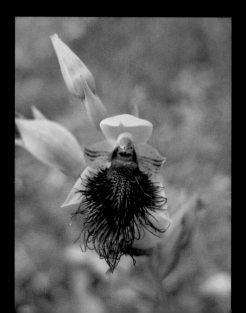

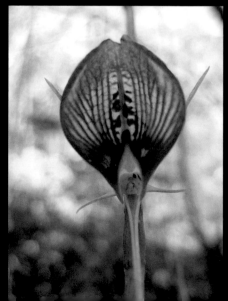

tartan-tongue and hyacinth orchid – were all shot handheld; I let the camera make most of the decisions for me while I concentrated on getting the composition right. In my view, digital compacts with good macro capability excel as tools for recording native flora – and actually, I feel, are probably better than DSLRs in this respect given their extended depth of field conferred by the shorter focal length of lenses employed in this type of camera.

Compact tip

Use the camera's LCD panel to review your shots. You instantly know whether you've succeeded in your photographic goal. This was not the case with film, and I now find I take fewer, but better pictures because of this built-in feedback mechanism that helps you learn what works and what doesn't.

Subject	Hyacinth orchid (*Dipodium punctatum*)
Camera type	Canon IXUS-Series (consumer type)
Pixels (x10^6)	7.1
Focal length	5.8mm (35mm on 35mm film format)
Exposure mode	Manual* and macro setting
Aperture	f/2.8
Shutter speed	1/250sec
ISO	80
Tripod	No
Flash	No
Additional points	*Although nominally manual, in reality, on this camera, this is a fairly automated exposure mode.

Subject	Cultivated orchid
Camera type	Canon IXUS-Series (consumer type)
Pixels (x10^6)	7.1
Focal length	5.8mm (35mm on 35mm film format)
Exposure mode	Manual* and macro setting
Aperture	f/2.8
Shutter speed	1/80sec
ISO	80
Tripod	No
Flash	No
Additional points	*Although nominally manual, in reality, on this camera, this is a fairly automated exposure mode.

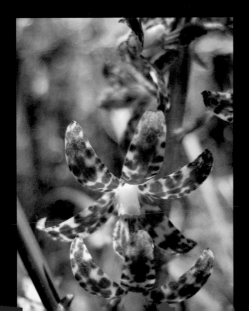

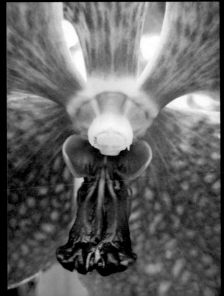

3 Landscape

Introduction

Landscape photography with your digital compact camera

I would guess that landscape is likely the most popular of all subjects for photography. This is also one area where image quality – and hence file size – is paramount. People like to hang good landscape prints on their wall, and the bigger you can print to, the better. In this respect a good DSLR will always beat a compact camera with the same pixel count. This is because the pitch of the pixels is greater in a DSLR due to a larger sensor. This results in higher-quality images that can be stretched that much further as 300dpi prints (industry standard resolution for printing). This fact notwithstanding, a 10-megapixel compact camera will still produce a fine reasonably sized landscape print of 20x15in (50x38cm) when sensitively rendered in Photoshop and subsequently interpolated within reason prior to final sharpening.

Landscape photography is always best when shot at the camera's lowest ISO setting. Some cameras are definitely better than others at resolving fine detail – particularly important in landscape work. The last thing you want is mushy detail in far off tree and vegetation limiting final print size. Again I urge you to read online reviews, which give honest accounts of what a camera is capable of. Remember, not all cameras perform equally.

Some of the major tenets of composing landscape scenes have been dealt with in my previous book – see *Succeed In Landscape Photography* (Rotovision), *Digital Nature And Landscape Photography* (PIP) and *Landscape And Environmental Photography: From 35mm to large format* (GMC Publications), which additionally cover many of the technical aspects of this photographic genre.

Although it is not my intention to go into a similar level of detail in this book, I nevertheless do draw attention to many of the key rules and important issues associated with landscape photography as applied to the digital compact camera. The crucial factor is to get exposures right in-camera, and I believe this is preferable to altering image density later in Photoshop – maybe this is the photographic purist in me.

Where I'm faced with a potentially outstanding landscape I apply a similar rigour to image capture as I might with a DSLR, or medium- or large-format film camera. That is I use a tripod, bracket my exposures, use the two-second time delay (equivalent of a cable release), explore all potential compositions, use a low ISO for extra detail and select the best time of day and hence lighting for the exposure.

If I had to give only three composition tips, these would be:

- Use the rule of thirds.

- Utilize diagonals or lead-in lines to draw viewers into or through the image frame.

- If possible, always include an element of foreground interest in the frame to anchor the more distant scenery. This provides extra dimensionality, which makes the scene more interesting.

Remove clutter

Isolate your subject

When it comes to landscape photography subjects, big is not always best. This small tropical waterfall with a shallow drop of only 18in (45cm) sat next to a huge fall with a drop of maybe 30ft (9m). Everyone else at this beautiful scene seemed to be interested in the large fall, be it for a paddle or a photo opportunity. Trouble was, it had no foliage around it, was in full sun and above the fall was an ugly safety barrier, and while I did take a couple of pictures of it, the real image was in the smaller cascade which was simply perfect in every respect – foreground rocks leading back to the small cascade, behind which was a large rock and tropical forest vegetation. All in all, the scene had lots of separate elements conspiring in harmony to provide depth, dimensionality and emotion to the vista. Closing the aperture down to its minimum setting permitted a long shutter speed adequate to blur the cascade's flowing waters and instill a verdant ethereal feel to the image. Needless to say a tripod was mandatory for this exposure.

Compact tip

Digital photography is essentially no different to film photography. However, to realize the full potential of digital photography you need to acquire some rudimentary photo-editing skills using programs like Photoshop Elements.

Subject	Tropical cascade
Camera type	Canon A-Series Powershot (prosumer type)
Pixels (x10^6)	10
Focal length	7.3mm (35mm on 35mm film format)
Exposure mode	Aperture priority
Aperture	f/8
Shutter speed	0.8sec
ISO	80
Tripod	Yes
Flash	No

Case Study 02

Introducing mood

Making the most of light

I shot this scene of isolated palms against a stormy backdrop on a South Pacific island. As you might guess from the sky, the heavens opened shortly after I took this picture. The quality of the moody light gives the picture an almost monochromatic feel, but despite the success of the image this was in fact a quick snatch shot before I headed for shelter – no tripod was used and little thought went into the technical aspects of exposing the scene.

Compact tip

Digital capture offers new ways of tackling panoramic views. Specialized film cameras were, and indeed still are, great for capturing panoramas, but digital can do the same thing using special stitching software. However, beware of moving subjects, particularly choppy seas, which don't stitch too easily.

Subject	Isolated palms against a stormy island backdrop	**Focal length**	Telephoto
		Exposure mode	Aperture priority (RAW capture)
Camera type	Canon G-Series Powershot (prosumer type)	**ISO**	80
		Tripod	No
Pixels (x10^6)	7.1	**Flash**	No

Comparing cameras

Compact vs DSLR

I was truly captivated by the beauty of this Cambodian landscape. It is actually an ancient moat at Preah Khan, which today is alive with lilies and lush vegetation. The coming together of clouds and their muted reflections, water and vegetation put me in mind of a John Constable painting, although this scene is a long way from Flatford Mill.

The picture uses the moat as a lead-in line which has dimensionality conferred by flowering lilies in foreground, and cloud and their reflections in the distance. I was sufficiently enamoured with this incredibly tranquil and photogenic scene to shoot it on both my 10-megapixel Powershot A640 and old 6-megapixel Canon EOS 10D DSLR cameras. As with the earlier Ta Prohm comparison (page 22), you can see here the merits of a neat, lightweight compact camera package when out and about. Image quality is excellent and it's a lot easier to carry around a compact camera than a DSLR and necessarily heavier tripod – especially if your mode of transport is a motorbike as was the case here!

Compact tip

Make sure you always have a few coins in your camera bag – not for a cuppa, but to loosen and tighten screws for tripod quick-release plates and to open camera battery compartments.

Subject	Moat, East Gate, Preah Kahn, Cambodia
Camera type	Canon A-Series Powershot (prosumer type)
Pixels (x10⁶)	10
Focal length	7.3mm (35mm on 35mm film format)
Exposure mode	Aperture priority
Aperture	f/4.5
Shutter speed	1/320sec
ISO	80
Tripod	Yes
Flash	No

Subject	Moat, East Gate, Preah Kahn, Cambodia
Camera type	Canon DSLR
Pixels (x10^6)	6
Focal length	17mm
Exposure mode	Aperture priority
Aperture	f/8.0
Shutter speed	1/80sec
ISO	100
Tripod	Yes
Flash	No

Additional points I'm pleased with the results from both cameras, but on this occasion I feel that the DSLR has the edge in terms of colour and composition. I think it really comes down to the fact that the zoom lens on the DSLR goes much wider than the zoom lens on the compact camera, and this scene needed a very wideangle perspective to get the most from the vista. Having said this, I'm splitting hairs and both pictures would be acceptable to most people in the final analysis.

Long exposures

Late evening light

I felt that this view had everything necessary to make a good landscape photograph. I was out gathering images for use online, and so only had a 5-megapixel camera with me. I would have liked something with greater resolution, as I think this scene would look good as a large fine-art print.

When I first came across this view the light was all wrong – harsh with any light colours blown out. I resolved to come back later, actually ten minutes before it was dark, and take pictures then with even illumination right across the scene. Exposures were a full 15 seconds and as a result smoothed out flowing water in the sinuous creek that dominates the foreground and which leads your eye into the scene. I also think that the eucalypts at right help lead the viewer into the scene.

This is not a famous vista; it could be anywhere, but to me all the visual elements fall just right. Obviously I used a tripod to shoot this scene, and although it contains only 5 megapixels of data, the file after post-production editing can print to 14in (35cm).

Subject	Jamison Creek, Darwins Walk, Wentworth Falls, New South Wales, Australia
Camera type	Canon A-Series Powershot (prosumer type)
Pixels (x10^6)	5
Focal length	9.6mm (46mm on 35mm film format)
Exposure mode	Shutter priority
Aperture	f/5.0
Shutter speed	1/15sec
ISO	50
Tripod	Yes
Flash	No

Case Study 05

Signature of place

The classic environment

A good landscape photograph does not necessarily need an obvious geographic label such as Scottish Highlands or American Southwest, it should be able to stand or fall on its artistic composition and technical merit. Having said that, there is nothing wrong with a photograph projecting a recognized context, that is a 'signature of place' if you will. This image of sclerophyll forest with a lone grass tree at right clearly shouts Australia – no mistaking the context here. However, careful composition takes this panorama beyond a simple record shot of a classic Australian environment. The grass tree at right anchors the whole scene – the eye slips across the panorama as if journeying through the actual environment – the amount of visual information here is high and provides much interesting content for a viewer's virtual journey.

This was a tricky image to execute, as it was a stitch put together from several individual frames on my 5-megapixel Canon G5. I was in an awkward position trying to ensure the grass tree

would remain in frame while keeping the camera square to both the horizontal and vertical axes – essential in ensuring accurate registration of frames when applying stitching software.

The accumulation of pixels from successive frames, a few tweaks of saturation and contrast in Adobe Photoshop, followed by some interpolation and sharpening have turned this into one of my favourite compact camera landscape images.

Compact tip

JEPG is a useful format that allows file compression and therefore permits more images to fit on your memory card. However, quality may suffer as a result of too many open-save cycles.

Subject	Grass tree and sclerophyll woodland panoramic stitch	**Shutter speed**	Unrecorded
Camera type	Canon G-Series Powershot (prosumer type)	**ISO**	50
		Tripod	Yes
Pixels (x10^6)	5	**Flash**	No
Focal length	Wideangle	**Additional points** A spirit level with pan and tilt tripod head were used with attention to retaining a constant horizon angle.	
Exposure mode	Stitch		
Aperture	Unrecorded		

Movie modes

My word, how things have changed. Ten years ago the pace of camera design and incorporated technology was, to put it politely, pedestrian! Today, the pace of development and the turnover of camera models, particularly in the overcrowded compact camera arena, is staggering. Indeed, the pace is such that any book on the subject is likely to be out of date by the time it hits the shops. However, so profound are the likely future changes to the market that I feel duty bound to allude to them, even though these thoughts may either be out of date, or proven wrong by the time you actually buy and read this book.

Convergence

To my mind the biggest change to the market for years is going to be the convergence of still and video capture. In some ways, compact cameras have always led the way in this area – most compacts have offered video-clip capture for years now. To give an example, a 10-megapixel compact camera that records movies at 640x480 pixels and 30 frames/ second will give around eight minutes of recording time on a 1Gb memory card. The quality of the AVI or MPEG files are fine for viewing in Windows Media Player, mostly they come with audio and sometimes interesting modes such as time-lapse. Great fun and, when reworked in a good digital video editing program like Adobe Premiere Pro or Sony

Compact cameras have always had the potential to make surprisingly good movies. DSLRs have now adopted this additional movie mode and we can therefore expect to see an increased market for moving pictures to parallel still images – particularly given the internet as a universal vehicle for all forms of media. This image of a crab was shot as a still JPEG, but given sufficient stability (i.e. a tripod), would have made a great subject for a short movie with its bubbles and slow motion. Why didn't I do this? I'm conditioned to think as a stills photographer. Like everyone else, I'm likely to start thinking more about moving images as the technology develops – and develop it will!

Video editing programs

Some of the programs available for editing video clips – from compacts, SLRs or pro-level video cameras – include Adobe Premiere, Sony Vegas, Pinnacle, iMovie (Mac) and Final Cut (Mac).

Vegas, can yield video that when tweaked, rendered and burned onto DVD produces near broadcast-quality media – certainly this is the case on my TV (not sure what it would look like on a giant plasma though). Even, free DVD authoring programs that come with your computer or DVD burner can do an admirable job of creating pleasing video CDs or DVDs.

However, at the time of writing, it is certain trends at the top end of the market that I believe represent the harbinger of tomorrow's techno-norm. Cameras are now being developed that are capable of both very high-quality still and video images. The Nikon D90 and Canon EOS 5D Mk II have started the trend off for DSLRs – the Canon, for example, recording at a HD resolution of 1,080 lines on a 20-plus megapixel sensor. You don't need to be Nostradamus to predict that this will become standard fare on many cameras in the future.

Tomorrow's digital compact

Some of you may question the need to know such things in a compact camera book. My reply is this. What you see in the top-spec professional DSLR of today will be in the consumer DSLR of tomorrow and the compact camera of the day after that. This is true of such things as image stabilization and megapixel count. So why not higher-quality video? The first generation of digital compact cameras is now coming through into the shops with 1,080 (30 frames/second) High Definition video integrated into their diminutive bodies. The Canon PowerShot SX1 IS is just such a beast – 10-megapixel resolution and HD video – all on a camera with a small 1/2.3in (6.16x4.62mm) sensor. My predictions at this point in time therefore seem quite sound. Of course the shoe has also been on the other foot for a while, with some HD camcorders

permitting still capture in addition to their primary role in shooting movies. One of the best examples in this respect is the Sony HDR-SR11/12 High Definition Camcorder. In its still capture mode it can achieve 10.2 megapixels, and is acclaimed to be very good at what it does. Video is recorded in the clarity and detail of full 1920x1080 HD resolution.

Have fun with your compact camera video – they're simply brilliant to play with, and quite capable of rendering video for web use that can be very professional in appearance.

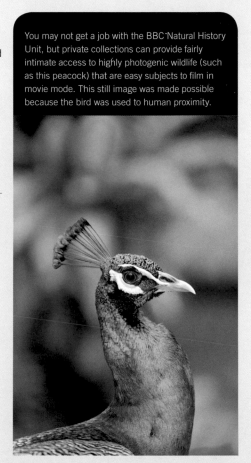

You may not get a job with the BBC Natural History Unit, but private collections can provide fairly intimate access to highly photogenic wildlife (such as this peacock) that are easy subjects to film in movie mode. This still image was made possible because the bird was used to human proximity.

Stabilizing your camera...

...without a tripod

This tropical waterfall in Khao Lak, Thailand, was an unexpected photo opportunity for me – it may not be the greatest cascade in the world, but it certainly deserved to be photographed.

I only had my Canon IXUS camera and no tripod with me, so in reality I wasn't adequately equipped to catch this scene in a way that might show it at its best. I worked around it by scrunching up my handkerchief, laying it on a convenient rock and firmly pressing my camera down into this makeshift camera support.

Subject	Ton Pling Waterfall-Khao Lak, Thailand
Camera type	Canon IXUS-Series (prosumer type)
Pixels (x10^6)	7.1
Focal length	8.5mm (51mm on 35mm film format)
Exposure mode	Manual*
Aperture	f/3.5
Shutter speed	1/100sec
ISO	80
Tripod	No
Flash	No

Additional points *Although nominally manual, in reality, on this camera, this is a fairly automated exposure mode. I used my handkerchief to support the camera against a rock.

Subject	Weeping Rock, Darwin's Walk, Wentworth Falls township, New South Wales, Australia
Camera type	Canon A-Series Powershot (prosumer type)
Pixels (x10^6)	5
Focal length	17.3mm (35mm on 35mm film format)
Exposure mode	Aperture priority
Aperture	f/5
Shutter speed	1/4sec
ISO	50
Tripod	Yes
Flash	No

I turned off the flash, set a low ISO and used the two-second timer delay. This approach worked well, but was truncated prematurely by a rainstorm. I'm not convinced how waterproof any of my compact digital cameras would be, even in light rain – one day I may find out, but not on this occasion.

The second fall here was again something I had not expected to come across – I had a 5-megapixel camera with me, but this time I did have a tripod, but this was still effectively a grab shot as I was racing back to beat the fall of night and on-off rainfall.

Where ambient light levels are too dim and limiting for decent shutter speeds, nothing can really substitute for a tripod. This next cascade (Jamison Falls) was taken on a 5-megapixel Canon Powershot camera, but with a tripod to keep the camera still during this early dusk exposure, which was sufficiently long to blur the cascade nicely – an effect I personally like. I often force this effect by dialing in a small aperture. This was again effectively a quick grab shot as I was trying to beat a storm and approaching darkness to head back to my B&B.

Subject	Jamison Falls, Darwin's Walk, Wentworth Falls township, New South Wales, Australia		
		Exposure mode	Aperture priority
Camera type	Canon A-Series Powershot (prosumer type)	**Aperture**	f/8
		Shutter speed	1/4sec
Pixels (x10^6)	5	**ISO**	50
Focal length	10.8mm (52mm on 35mm film format)	**Tripod**	Yes
		Flash	No

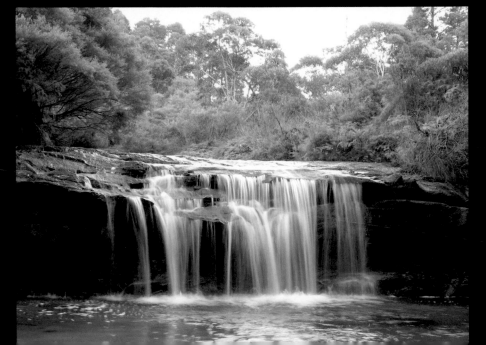

The dynamic landscape

Using action

I wasn't sure whether to slip this image into
the travel or landscape category of this book.
After some thought I believe it belongs here, in
landscape. It shows a long-tail boat ploughing
across the water of Phranang Bay in Thailand.
I like this image as it has a sense of place,
is dynamic – something is clearly happening,
but is also aesthetically pleasing in terms of
composition, colour and harmony. I would hang
this on my wall.

Compact tip

*Thinking of buying your first digital camera, or upgrading
your kit? Then check out some of the outstanding
websites that review the latest camera equipment.
Try dpreview.com, luminous-landscape.com,
fredmiranda.com, steves-digicams.com,
robgalbraith.com*

Subject	Long-tail boat at sea, Phranang Bay, Thailand		
Camera type	Canon A-Series Powershot (prosumer type)	**Exposure mode**	Aperture priority
		Aperture	f/5
		Shutter speed	1/160sec
Pixels (x10⁶)	5	**ISO**	50
Focal length	29.2mm (140mm on 35mm film format)	**Tripod**	No
		Flash	No

Case Study 08

The telephoto end

Compressing perspective

This picture was taken on Lord Howe Island, a UNESCO World Heritage Site in the Pacific Ocean, and conjures up a remote desert-island feel that could be straight out of the set for the TV series *Lost*.

I could see the picture I was after in my mind's eye before I actually composed it. The secret here was to stand back and use a telephoto setting that compressed perspective, making the foreground palm trees become a relatively dominant force within the frame –

remember these trees are minuscule relative to the immense monolithic structure of Mount Gower in the background. However, it is the listing palm tree that really makes this picture work, and it was the element that first alerted me to the fact that there was a good picture to be made here. I used a high-quality Canon G6, 7-megapixel compact camera to expose this scene and shot in RAW format for maximum post-capture control of exposure parameters such as white balance and contrast etc.

Subject	Palms set against Mount Gower, Lord Howe Island	Focal length	Telephoto
Camera type	Canon G-Series Powershot (prosumer type)	Exposure mode	Aperture priority (RAW capture)
		ISO	80
		Tripod	Yes
Pixels (x10^6)	7.1	Flash	No

Photography masterclass
Telephoto compression

Most people out to shoot the intimate scene of a bluebell woodland would opt for a wideangle rendition. Here I opted to use a telephoto lens as it compressed the carpet into something that seems denser and more significant than it would if I had used a wideangle.

With a compact camera you would definitely need to deploy a tripod to achieve anything like this image. Select a smallish aperture and the lowest ISO. The bluebells may need a tweak in postproduction editing to bring out the best colour.
I prefer a wideangle for most landscapes, but there are definitely times that a longer lens works better.

The vantage point

Appearances can be deceptive

A good photographer will always be on the lookout for a photo opportunity, although sometimes they can appear when you least expect them. By way of example, I was staying in a holiday bungalow next to the sea – and although the scene from my balcony was beautiful, it had too much chaos and not enough harmony to justify a serious photograph. However, five feet to my right and from a very low angle all the clutter and chaos disappeared and I could shoot this coconut palm with lots of nice foreground foliage. If there is a motto here, it is think about the scene and recognize that where you shoot from – your vantage point – is critically important.

Compact tip

When composing a landscape try to keep the orchestration simple and ordered. Look for foreground interest. Always avoid clutter and distracting elements that disrupt harmony. Also, keep the rule of thirds in mind at all times.

Subject	Coconut palm
Camera type	Canon IXUS-Series (consumer type)
Pixels (x10^6)	7.1
Focal length	7.3 mm (44mm on 35mm film format)
Exposure Mode	Manual*
Aperture	f/3.5
Shutter speed	1/160sec
ISO	80
Tripod	No
Flash	No
Additional points	*Although nominally manual, in reality, on this camera, this is a fairly automated exposure mode.

Case Study 10 The 360-degree panorama

Rainforest interior

I have already alluded to the fact that static scenes are best for constructing panoramic photo stitches – dynamic scenes are still best shot on a film panoramic camera due to problems of frame registration when stitching. However, from what I have seen, some of the most interesting possibilities for photo merges are intimate, closed-in scenes shot full circle: that is, a 360-degree view of the immediate surrounds. Many of these seem to be of urban subjects that probably stitch better than natural scenes, which often have lots of leaves and branches to confuse the stitching software. Despite this I thought it would be interesting to catch a 360-degree panorama of the interior of a rainforest. I placed a monstrous turpentine tree at left to anchor the scene and allowed the rainforest trail to act as a natural path through the frame – I took this on a 5-megapixel Canon G5 and merged the scene using Canon's proprietary software. The final rendering was done in Adobe Photoshop. What is shown here is roughly a 270-degree crop of the full circle.

Compact tip
If you venture far off the beaten track, a mobile phone could be your most important accessory – have it with you at all times.

Subject	Sub-tropical rainforest: 270-degree crop from 360-degree circle
Camera type	Canon G-Series Powershot (prosumer type)
Pixels (x10^6)	5
Focal length	Wideangle
Exposure Mode	Stitch
Aperture	Unrecorded

Shutter speed	Unrecorded
ISO	50
Tripod	Yes
Flash	No
Additional points	A spirit level with pan and tilt tripod head were used with attention to retain a constant horizon angle.

Urban nightscapes

Camera comparison

This image of Circular Quay in Sydney was taken from virtually the same vantage point as the night shots on page 29 in the travel section and, as you can see, I shot a little late as all the blue had been lost from the sky. This is really beyond the optimum time to shoot cityscapes, as images look better with some colour remaining in the heavens as opposed to rendering an inky black sky. Also, with that extra bit of ambient light left in a scene, artificial city lighting doesn't burn out so easily and lead to greater exposure difficulties due to the extreme dynamic range within the image frame.

I used a small, 8in (20cm) flexipod to support the camera on a railing. From a compositional perspective, it is difficult to take a bad shot of Circular Quay; however, time of day is also important and this urban gem looks infinitely better when lit up at night.

Subject	Circular Quay, Sydney, Australia	**Aperture**	f/4.5
Camera type	Canon A-Series Powershot (prosumer type)	**Shutter speed**	Six seconds
		ISO	50
Pixels (x10⁶)	5	**Tripod**	Yes, small flexipod
Focal length	7.8mm (37mm on 35mm film format)	**Flash**	No
Exposure mode	Shutter priority		

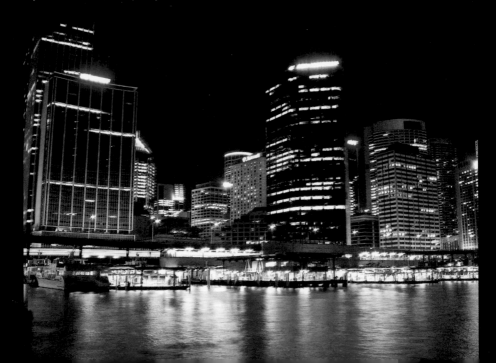

The second image here shows the same scene shot at the correct time of day, albeit using a DSLR. The difference in image appeal is immediately apparent. Both pictures are successful, although the DSLR one is better – not because of the larger camera sensor, it's just a better composition with better colour. In terms of quality, I can interpolate the DSLR file to 24in (60cm) and the compact file to 14in (35cm) before the first signs of a breakdown in image structure. This difference in ultimate print size is not proportional to the difference in pixel count, which differs little. However, it does relate to pixel size, which differs greatly given the difference in the dimensions of the two sensors. As a photographer, you need to decide how large you will want to print – most will be quite happy with the print size from even a 5-megapixel compact camera, as here.

A point to note is that both images required manual exposure control and a shutter opening of several seconds – and given the ability to exert this level of control, it is difficult to fault the utility and clear potential of such a small, pocketable camera.

In my view some of the most interesting, indeed visually arresting landscapes are urban nightscapes – particularly those taken during the critical crossover light of dusk. I continue to craft cityscapes with my DSLR, as I can extend exposures way beyond the 15-second limit on my compact camera, but clearly even 15 seconds opens up all manner of possibilities. The DSLR image required a 45-second exposure – three times the maximum of my compact camera. Despite this I still regularly shoot evening scenes on my Canon Powershot cameras.

Subject	Circular Quay, Sydney, Australia	Shutter speed	45 seconds
Camera type	Canon DSLR	ISO	100
Pixels (x10^6)	6	Tripod	Yes
Focal length	40mm	Flash	No
Exposure Mode	Manual	Additional points	Cable release used
Aperture	f/8.0		

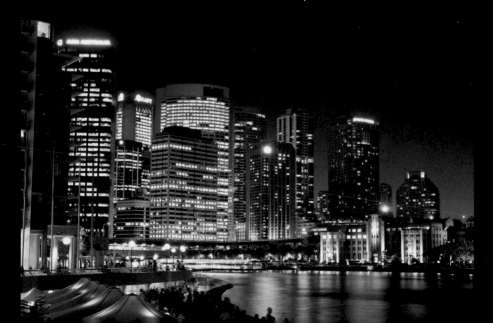

The wideangle converter

A broader view

Wideangle lenses are often considered to be the staple tool of landscape photographers, for good reason. They alter perspective and embrace a much broader field of view. Unfortunately, the majority of compact cameras do not have an extreme wideangle perspective – most are truncated in the 32–36mm range (35mm film format equivalent).

One way of working around this problem is to buy a camera that offers accessory bolt-on wideangle and telephoto adaptors. In the case of my Canon Powershot cameras I have a wideangle adaptor (wide-converter WC-DC58N) which provides the equivalent angle of view to that of a 24mm lens on the 35mm film format.

This produces outstanding quality images – but is a heavy package and in some ways undermines the convenience of carrying around a small pocketable compact camera. Despite its size and weight drawback it's important to me to have this option available.

The picture of sclerophyll woodland shown here gives an idea of how a 24mm adaptor can alter perspective, giving not just a wider angle of view, but also outstanding depth of field. Examine how the leaf litter in the foreground is razor sharp and the trees in the background are also still nice and sharp.

Subject	Leaves and twigs on forest overlook
Camera type	Canon A-Series Powershot (prosumer type)
Pixels (x10^6)	5
Focal length	7.3mm (35mm on 35mm film format, but with lens adapter – the wide converter WC-DC58N – the final 35mm film format equivalence is 24mm)
Exposure mode	Aperture priority
Aperture	f/8.0
Shutter speed	0.4sec
ISO	50
Tripod	Yes
Flash	No

Case Study 13

Reflections

Abstract images

Look for abstracts in the reflections from water, as you might in a cloudy sky at sunset. This abstraction illustrates the reflections of a flame-red setting sun in the placid waters of a harbour. This is a simple photograph, but is effective in its artistic content and looks good as a small print – especially when set against a bold, black border. No thought as to exposure went into this image – it was simply a case of point and shoot – there is no context to the image, it is generic and could have been made almost anywhere on the planet.

Subject	Setting sun in placid harbour waters	Exposure Mode	Aperture priority
		ISO	50
Camera type	Canon G-Series Powershot (prosumer type)	Tripod	No
		Flash	No
Pixels (x10^6)	5	Additional points	A similar effect can be achieved with clouds.
Focal length	Telephoto		

Sensor size

As great as compact cameras are, they are particularly deficient in one respect. Because they have such small sensors, the photosites are necessarily small. This means as you increase ISO (analogous to film speed in the days of film), the electronic amplification process that increases their sensitivity to light leads to noise or graininess. This undermines image quality. At their lowest ISO, compact cameras truly shine, but it only takes a minor increase, say from ISO 80 or 100 to ISO 200, and especially ISO 400 to kill a picture should you want a reasonable-sized print from your camera.

Digital SLRs have much larger sensors. The latest crop of Nikon and Canon 12–25 megapixel, full-frame sensors are amazing at reducing noise at the highest ISO settings. However, for the purposes of this section, rather than compare a consumer compact with a pro-level, full-frame DSLR, I've opted to compare a fashion style 7.1 megapixel Canon IXUS compact camera and a popular crop frame DSLR camera that packs a significant 15.1 megapixels onto its APS-C-sized sensor

– the Canon EOS 50D. The outcome can be predicted with ease, but there are still lessons to be learned. In order to see the ISO effect clearly, I have shot the same subject on each camera at ISO 100, 200, 400, 800 and 1600. For good measure the IXUS profile includes an ISO 80 shot and the 50D an ISO 3200 image. To a certain extent, comparing apples with oranges comes to mind in this exercise, and after some consideration, I decided to only select areas in the frame that were in sharp focus for this ISO comparison – even if they were of different regions within the field of view. It's not possible to compare noise so easily in out-of-focus zones. I shot a fabric lily on my kitchen worktop as the subject, and the EOS 50D had an f/2.8 70–200mm zoom attached. The digital SLR images were of the reproductive structures of the flower, while the compact camera images were of the wood

This screengrab shows the lowest ISO images for both a DSLR (top row) and a compact camera (bottom row). I include the very highest ISO settings for each camera as a quick point of reference. The ISO is shown at the head of each individual file. The navigator box shows the area examined in the compact camera.

slats on my outdoor decking, which the camera chose instead of the flower as the point of sharpest focus – no matter. The images I've selected here show the effects of noise quite clearly in both cameras.

There are two screen grabs to examine. The first shows the lowest ISO images for both cameras, but includes the very highest ISO settings as a quick point of reference. The second shows the highest ISO settings. If you are after the best either camera can offer, it's clear that the digital SLR is noise-free at ISO 100 and 200, with noise only becoming evident at ISO 400. However, even at this latter sensitivity, the image is quite useable. At ISO 800 and above, noise is easy to see, and becomes progressively worse. Similarly, the compact is great at ISO 80 and 100, but by the time you get to ISO 400 and above, noise is clearly evident. The noise in the compact camera is unpleasant though, causing blocking/

lumping of pixels, and a loss of fine detail. By contrast, nothing but fine detail is still evident in the DSLR files right up to ISO 1600. No images have been modified post-production, and all are presented at 300 per cent.

Noise

The two main types of sensor-induced noise are related to colour and luminance. Hence the terms colour (chroma) noise and luminance noise. Both these types of noise are diminished as image brightness increases, and this is related to a higher signal to noise ratio. If you underexpose a scene or shoot night scenes, you introduce noise artefacts that will remain even if you brighten the image postproduction, i.e. with the Levels or Curve tool in Photoshop. Marginally overexposed images are cleaner, and have relatively less inherent noise than underexposed scenes.

Of the two types of noise, chroma noise is the pain, and can spoil an image if too intense. Luminance noise on the other hand is actually necessary. If you remove this latter noise altogether, you will render a very waxy-looking image that is quite unnatural – to my mind, some of the earliest digital cameras seemed to suffer from this problem.

This screengrab shows the highest ISO images for both a DSLR (top row) and a compact camera (bottom row). The DSLR out performs the compact camera, as you might predict. Noise is a real problem in compact cameras beyond ISO 400.

In the test images here, I see retention of fine detail and mostly only luminance noise from the DSLR as ISO increases. However, the artefact blocking up of the pixel matrix which occurs in the compact camera shots is more problematic, and inevitably causes a tail-off in fine detail with this type of camera. It's important to note that there are programs around that are designed to reduce image noise, one example being Noise Ninja. If this pixel peeping serves any purpose, it illustrates that there has to be a theoretical limit to the design of sensors – only so many pixels can be accommodated before high ISO noise causes a loss in image quality. This is clearly a plateau effect – and we are approaching that plateau right now. To push the limits of what's possible; manufacturers are using micro-lenses above each sensor photosite to amplify the light, and to further assist, they are reducing the distance between sensor photosites as a mechanism to increase pixel density. Where will it end – I have no idea.

File size

Of course, as pixel count increases so does file size. To give this context, the test shots taken here on the Canon EOS 50D DSLR when examined straight out of the camera represent

A good macro shot needs to render as much detail as possible, hence the setting of ISO 80 for this image of *Isopogon anethifolius*, or narrow-leaf conebush. Handholding at 1/60sec is perhaps pushing it a little with macro, but the result is a photograph that renders the bright colour in all its glory, as vividly as possible.

Canon IXUS 75 at 5.8mm, ISO 80, 1/60sec at f/2.8

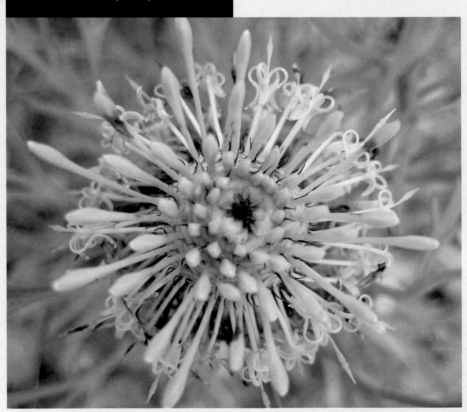

114

43-megabyte 8-bit TIF files, 86-megabyte 16-bit TIF files and for future users 172-megabyte 32-bit TIF files. The good news is that 8-bit JPEGs are only 4.8 megabytes in size. For serious use, storage of postproduction files in TIF format is advocated, but it's clear that in this format, file size associated with a higher pixel count can also become a limiting factor. I suspect that more people will shoot and store images as JPEGs as file sizes increase.

This comparison of three compact camera images reveals how, as ISO increases, so do noise levels.

Memory card 80

Memory card 400

Memory card 1600

Pattern and repetition

Go for the bold image

This is an image I would be happy to hang as wall art. Alternatively, one could also use the image for a travel article or other related editorial use, such is the grey area of overlap between landscape and travel photography.

In this image the stone Buddhas recede into the distance forming a diminishing, but dominant line into and through the frame. However, it's the vivid yellow robes adorning each statue that provide an unusual and bold graphic, lifting the image from the ordinary

into the extraordinary. I used a high-quality 10-megapixel Canon Powershot camera to expose this scene, which was taken at Ayatthaya, a UNESCO World Heritage site bristling with similar photographic gems.

The position of the lead-in line was composed on the vari-angle LCD screen of my Powershot camera and several exposures were made handheld before a critique of image sharpness in review mode satisfied the perfectionist in me.

Subject	Receding Buddhas	**Exposure mode**	Aperture priority
Camera type	Canon A-Series Powershot (prosumer type)	**Aperture**	f/3.5
		Shutter speed	1/1000sec
Pixels (x10^6)	10	**ISO**	80
Focal length	14.9mm (71mm on 35mm film format)	**Tripod**	Yes, small flexipod
		Flash	No

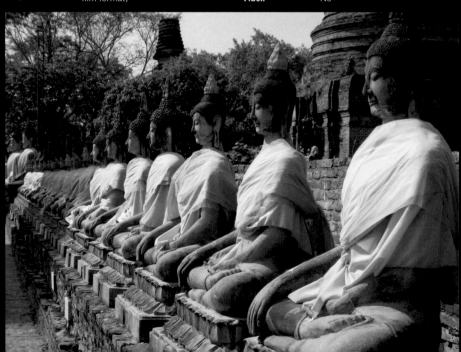

Case Study 15

Framing a scene

Combining different elements

Cityscapes that look drab and tired during the day can bounce back to life when the neon lights power up. I had already shot some pictures of this building the night before on my DSLR. However, this night I was forced to shelter from a brief shower under a doorway a little off the beaten track. I couldn't believe how serendipity had intervened when I looked up and saw the building framed by a tree with plenty of neon to provide pizzazz to the shot.

I'd liked to have had a slightly wider lens, but by getting low and angling the compact camera upwards I found a composition that worked well. I shot several frames because of the difficulties in hitting the right exposure. Bright lights can fool meters into underexposing so it's a good idea to shoot around what the camera recommends if you have a compact that has this level of flexibility. This image prints fine up to 16in (40cm) and at that size you wouldn't know it wasn't taken on a 25-megapixel DSLR.

Compact tip

If shooting long exposures with a tripod-mounted camera always use either a cable release or two-second self-timer to minimize camera shake.

Subject	Skyscraper at night
Camera type	Canon A-Series Powershot (prosumer type)
Pixels (x10^6)	10
Focal length	7.3mm (35mm on 35mm film format)
Exposure mode	Aperture priority
Aperture	f/4.5
Shutter speed	Two seconds
ISO	80
Tripod	Yes
Flash	No

Drama and spectacle Case Study 16

Varying compositional approaches

Some of our planet's most magnificent natural scenery is represented by limestone karsts. The best places to observe and shoot this rugged landscape form are Vietnam, Laos, China and Thailand. Bear in mind that this visual feast is lived in and you sometimes have to work at crafting an image free from unwanted modern human intrusions. Nevertheless, the potential for outstanding images is high.

I have included three images here that take different approaches to catching karst scenery. The first looks down upon a receding plain of karsts enveloped by a tropical downpour. This was shot at the extreme end of the telephoto setting and has compressed perspective very well. The second image is taken from within a cave at the base of a karst and shows the surrounding 'jungle' vegetation, which was very

Subject	Karsts from Wat Tham Seua, Thailand
Camera type	Canon A-Series Powershot (prosumer type)
Pixels (x10^6)	5
Focal length	29.2mm (140mm on 35mm film format)
Exposure mode	Aperture priority
Aperture	f/4.5
Shutter speed	1/125sec
ISO	50
Tripod	No
Flash	No
Additional points	Rested on a rock using a crumpled handkerchief to cushion the camera.

Subject	Cave at base of karst looking into rainforest 'hong', Thailand
Camera type	Canon A-Series Powershot (prosumer type)
Pixels (x10^6)	5
Focal length	7.3mm (35mm on 35mm film format)
Exposure mode	Aperture priority
Aperture	f/4.5
Shutter speed	0.3sec
ISO	50
Tripod	Yes
Flash	Yes
Additional points	Fill flash was used to illuminate the cave interior while ambient light exposed the exterior rainforest.

Compact tip

If hiking in wet or inclement weather, have a resealable freezer bag with you to completely protect your camera – useful on a sandy beach, as well.

lush and popular with mosquitoes. The final image shows Khao Kanab Nam on the Krabi River. I'm told that Khao Kanab Nam translates into 'dog ears', which seems apt. This karst is a well-known landmark on Thailand's Krabi River. You may have seen this scene in some of Hollywood's jungle movies of recent years. I shot all these views on a 5-megapixel Canon Powershot camera and results were excellent.

Subject	Khao Kanab Nam on the Krabi River, Thailand	**Aperture**	f/5.6
		Shutter speed	1/800sec
Camera type	Canon A-Series Powershot (prosumer type)	**ISO**	50
		Tripod	No
Pixels (x10^6)	5	**Flash**	No
Focal length	29.2mm (140mm on 35mm film format)	**Additional points**	Rested on a wall using a crumpled handkerchief to
Exposure mode	Aperture priority		cushion the camera.

Photography masterclass
Building in a focal point

This image is great because it works at a number of levels.
The water and rocks provide compelling foreground interest while
the distant mountains (Skiddaw) and lake (Derwentwater)
provide an equally interesting backdrop. However, it's the middle
ground taking in the packhorse bridge itself that is the
true focal point of this scene.

It draws you to it and provides a superb example of a feature that
anchors everything in frame together. It doesn't matter what camera
you use, what matters is how you see with it – how you compose all
the elements into something that hopefully hangs together.

With time, this will become intuitive, but when starting out
it really helps to open your mind to all the possibilities.
Incidentally, this scene was taken with a standard lens,
and so is doable with any compact camera.

The classic sunset

Improvising support

I had been out walking and didn't really have a view to shooting any pictures, but had my compact camera tucked away in my day pack. When this sunset appeared I was glad I had it at hand, but in the absence of a tripod, I had to go searching for an alternative camera support. Luckily I found a fencepost that I embellished with my wife's scarf. This provided a stable nest to force my camera against as I shot this fiery scene using the two-second self-timer function on the camera to quench camera shake. The long end of the zoom lens was used and this unfortunately tends to exacerbate any camera shake.

I took several frames, but prefer this one with some foreground detail included in frame. Auto shooting sunsets with a compact camera often leads to slight underexposure, especially if the sun is particularly bright. This often works in the photographer's favour by deepening colour intensity and forcing a shorter exposure time. This frame was taken at 1/200sec – okay for handholding, but within a couple of minutes the sun had dropped and illumination was so low that blur would have been a problem had I not supported the camera.

Subject	Sunset over river
Camera type	Canon A-Series Powershot (prosumer type)
Pixels (x10^6)	10
Focal length	21.7mm (104mm on 35mm film format)
Exposure mode	Aperture priority
Aperture	f/7.1
Shutter speed	1/200sec
ISO	80
Tripod	No
Flash	No

Case Study 18

Unusual vantage points

Use your imagination

Sometimes it pays to engage the imagination and scout around for the best vantage point. Most people shoot at the first opportunity – I advocate you spend a little time injecting imagination into the composition. In the case given here I wanted to shoot a true panoramic cityscape, but at ground level nothing gave me what I had in my mind's eye, so I went to the top of another building to create the bird's eye view that I was after.

Not having a true panoramic camera with me I needed to shoot several frames and stitch them together. One of the biggest problems was that I was shooting through tinted glass windows and needed to ensure that I missed any light reflection or refraction – quite a tall order. Another problem was using a tripod where there was significant pedestrian traffic. Remember, unless you have public liability

insurance, you're liable for any injury you might cause due to your tripod! Indeed, in some places where there is significant pedestrian traffic, tripods may be banned. In this case I hugged my gangly presence around the tripod to prevent anyone tripping over it.

Compact tip

Before employing a third party to set up your website – have a go yourself, you might be surprised how simple it can be.

Subject	Cityscape from the top of another building	**Exposure mode**	Aperture priority
Camera type	Canon A-Series Powershot (prosumer type)	**Aperture**	f/4.5
		Shutter speed	1/80sec
Pixels (x10^6)	10	**ISO**	80
Focal length	12.6mm (60mm on 35mm film format)	**Tripod**	Yes
		Flash	No

Working quickly

No need for a tripod

This colourful mottled sky lasted only a couple of minutes and was quick and easy to record. The auto exposure setting can actually help to enhance the graphic quality of an image taken at this time of day: the excessively bright light of sunset leads to marginal underexposure, creating silhouettes of trees and, if present, buildings. It also enhances the intensity of any crimson or orange hues in the sky. Remember that with bright scenes such as this shutter speeds are fast, so you don't need to bother with a tripod or much in the way of camera support (in this case the shutter speed was 1/200sec). A useful tip is to pre-focus (and hence pre-meter exposure) on (several) points along the horizon before reframing the scene and tripping the shutter. This way you will achieve a degree of rudimentary bracketing, and more likely nail the optimum exposure.

Subject	Flash of colour at sunset	**Exposure mode**	Aperture priority
Camera type	Canon A-Series Powershot (prosumer type)	**Aperture**	f/6.3
		Shutter speed	1/200sec
Pixels (x10^6)	5	**ISO**	50
Focal length	23.4mm (111mm on 35mm film format)	**Tripod**	No
		Flash	No

Case Study 20

Overcast conditions

The perfect landscape light

What makes this work for me is the *Lord of the Rings* ambience. The dank, ferny world of trees encrusted in a mask of moss and lichen completely insulates voyeurs from the bright sun that the rest of the world was enjoying on this particular day. This dark, moist microenvironment was maintained because it occurred in a shaded chasm – nirvana for photographers. I happen to enjoy shooting verdant wooded scenes, and so this kind of scene always appeals to me wherever I am in the world. Care is needed though. The shutter speed was a slow 0.4sec, so I needed a lightweight tripod to ensure a shake-free, sharp image. With this kind of intimate landscape

you should make sure the flash is off and the camera is on a rock-solid support if you want an image that you can print up to a decent size – perhaps to hang on the wall.

Compact tip

The ISO setting of your digital camera is analogous to film speed, but is different in that instead of an increase in grain with increasing film speed, a digital camera exhibits an increase in noise. For landscapes, always use the lowest ISO setting possible to ensure the sharpest images.

Subject	Verdant foliage in canyon
Camera type	Canon A-Series Powershot (prosumer type)
Pixels (x10^6)	5
Focal length	7.8mm (37mm on 35mm film format)
Exposure mode	Aperture priority
Aperture	f/3.5
Shutter speed	0.4sec
ISO	50
Tripod	Yes

Postproduction

I hope that if this book achieves one thing, it is to dispel the myth that you require an expensive DSLR to catch good, even outstanding images. The final picture requires the right subject, and a good photographer. As far as equipment is concerned, it should be adequate to the task. Believe me, for most travel and landscape subjects a good 10-megapixel prosumer camera is quite adequate. True, for these genres of photography, I can get larger prints of a better quality with my 12.8-megapixel full-frame Canon EOS 5D DSLR with all-purpose 24–105mm L series lens, but this is a fair-sized camera and draws attention to me when I want to shoot in a stealthy fashion. I won't contest the issue that DSLRs reign supreme for wildlife photography, but hope you appreciate from my images in this book that even for this subject matter a good compact can turn in results that are excellent by any standard. However, whatever route you take – DSLR or compact camera, your pictures can always be improved with a little post-capture processing. The following is designed to help you understand the structure of an image file and how to use typical photo-editing software to bring out the best from your pictures.

Understanding resolution

The fundamental unit of a digital picture is the pixel. If the resolution of your file is too low, then you will see the pixels or dots in the picture – in other words the picture has pixellated. You often see this effect in newspapers where low-resolution JPEGs from camera phones have been blown up too big and used. Let's examine pixels and try to gain an understanding of the concept of resolution. You should always think of pixels as the equivalent of film grain – they are the fundamental light-responsive unit of the imaging chip.

Everybody is obsessed by pixel count – how many, what size, how large can you print. Well, the fact of the matter is that a digital file has no absolute dimension in terms of resolution and size, as we have become accustomed to

with respect to transparencies, negatives and prints. What it has is a defined number of pixels. It is always up to us to define how these pixels are distributed per unit area. We can stretch these pixels over a large area or cram them into a smaller one. In either case the resolution (or pixel density) will be different.

There are goals to achieve. To produce a print that has high-end photographic characteristics, you need to be able to print to a linear resolution of 300 pixels per inch or ppi (ppi is essentially analogous to dpi). This means that if you want A4 output (final print size), the original digital input file that you captured must have sufficient resolution to

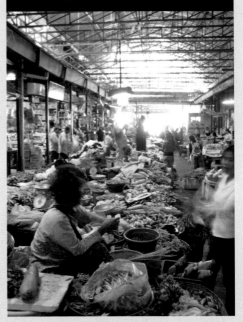

This image was taken at f/2.8 and has a remarkably good depth of field. This is a crucial advantage to shooting with a digital compact camera, as it has a far wider depth of sharpness than that of a DSLR.
Canon IXUS at 5.8mm focal length, ISO 80, 1/2sec at f/2.8

maintain a spread of pixels that can achieve 300 pixels every inch over the dimensions of an A4 sheet of paper. In reality, however, it is quite possible to drop below 300ppi and still produce good prints – one's eyesight is unlikely to see any difference between 250 and 300dpi output. Even 180dpi may do the job!

Pixel size

Always be aware, though – there are considerations other than the number of pixels alone. Pixel size, or what I referred to earlier as pixel pitch, is also a very important factor in image quality. Compact-style digital cameras often have high resolution yet always have small sensors. Most digital compact cameras use a sensor around a quarter the size of a 35mm frame of film. What this means is that there are a lot more photosites on these sensors than on larger DSLR sensors. These photosites are therefore a lot smaller and consequently extract a price in terms of increased noise and propensity for chromatic aberration. The larger photosites/pixels found on DSLR sensors are far superior in producing quality images, with noise in particular being better controlled (this is because the photosite signal needs less amplification).

However, as I have already alluded to, there is an upside to a small sensor – that is the necessary reduction in focal length needed to facilitate a wideangle to moderate telephoto zoom lens. This reduction yields very short focal length lenses with an almost infinite depth of field, even at apertures of f/4 and below. The increased depth of field with these small-sensor digital compacts is a major plus point for landscape photographers. To quantify this, my Canon Powershot cameras have a lens multiplication factor of 4.79x, while my Canon IXUS has a lens multiplication factor of 6.03x. You can immediately see from this that the IXUS has the smaller sensor.

Interpolation

In addition to learning that there is more to image quality than pixel number, I shall apparently contradict myself. Earlier I said that you could only make your input pixels go so far in terms of size of print output.

While this is essentially true, there are some miraculous things that you can do to bend this rule. Basically, you can upsize your image file using 'interpolation' software such as Genuine Fractals, Extensis pxl SmartScale or the various built-in utilities of Adobe Photoshop.

For instance, pxl SmartScale allows you to 'resample' or rescale an image by up to 1600 per cent. The loss in quality is minimal, and brightness and colour data is preserved. This product is a plug-in for Adobe Photoshop, and is the technique I tend to use most often, but Photoshop has its own methods of rescaling (resampling) an image, the most popular being 'bicubic resizing'. Bicubic resampling is preferable to 'nearest neighbor resizing', but takes a bit longer. The menu to achieve this in Photoshop can be found by following the path – Image>Image Size. Ensure that you constrain proportions and select the resample image box, then enter a final resolution of 300 pixels/inch and set your size requirements. If you use this utility it is a good idea to use bicubic smoother to enlarge your image file and bicubic sharper for reducing it.

Interpolation may seem a bit of a cheat, but chances are that the next large poster or billboard sign you see will have been produced using this technique. The mathematical algorithms that underpin this software look at how each pixel fits in relation to its neighbours. The software then adds pixels to the image to permit a bigger print to be made – something for nothing! You can use interpolation software to yield super-sized prints.

As I have just mentioned, in addition to 'rezzing' up image files, you can shrink them as well. For instance, you might want to 'rez-down' an image if preparing it for web use. In this case your aim is 72dpi output, which is the standard for computer screen resolution. Basically you resize your picture in Photoshop or other software, which discards unwanted pixels, shrinking file and output size. As mentioned, the industry standard for high-quality magazines and top-end printing is 300dpi (sometimes 400dpi). I use 300dpi as my benchmark when defining output parameters. All the images in this book were processed in Photoshop, then interpolated and sharpened to yield a 300dpi master file. These master files were then scaled down

in height and width, but not in resolution to accommodate the reproduction size requirements for this book.

Master files

For a good image file derived from my 10-megapixel compact camera I will typically produce a 15x20in (38x50cm) master file. A good file from my consumer-level 7-megapixel Canon IXUS will generate an 11x15in (28x38cm) master file. Compare this with the master files I produce with a 12.8-megapixel DSLR which yield 20x30in (50x76cm) prints when carefully processed from RAW files.

To summarize, the larger and more prevalent the pixels, the better the image, and the larger you can print. Don't set your goals in stone, however; as I mentioned before, you would have to have a very keen eye indeed to detect the difference between a file at 250dpi versus one at 300dpi output at A4. Also, despite the maths, camera processors have a lot of influence on quality, as does the clarity of a lens. This is particularly noticeable when you compare the image quality of 8 and 10-megapixel DSLR files; high-quality L series Canon glass on the 8-megapixel DSLR beats cheap glass on the

10-megapixel camera every time. As far as digital compact lens quality is concerned – read the various online reviews to gauge which camera would be best for you.

Workflow

Workflow is the process of taking the camera file and processing/enhancing, storing and, where required, printing it. This process is different for everyone, and what I suggest here is only one of several possibilities.

To process a single image in the way shown in the Order box (opposite) will take five to ten minutes, but it's time well spent when you see what a difference this can make to an image. I must add a caveat here. Some

This screen grab shows how to interpolate using Adobe Photoshop. Subjects with little detail such as a human face, sky or, as here, Buddha's gold feet can be interpolated further and with greater ease than images full of native detail and texture. To increase a file's size for larger prints go to Image>Image Size and set resolution to 300dpi, with your target dimensions keyed in. Then select bicubic smoother to resize the image as shown in the screen grab.

Order

1. Download files to computer or laptop. The options are to remove the memory card and use a card reader (my preference) or to plug the camera directly into the computer.

2. Archive the crude downloaded files to CD or DVD and to an external hard drive dedicated to crude image files.

3. Browse crude files using any one of several commercial programs. I favour Adobe Bridge and Lightroom.

4. Open the best files, process in photo-editing software as follows:

 a) Convert to Adobe 1998 colour profile (depends on your use; this is my preference based on commercial needs). The method to do this in Photoshop CS is Image> Mode> Assign Profile> Select Adobe RGB 1998.

 b) Crop as required.

 c) Use levels (Image> Adjust> Levels) or curves (Image> Adjust> Curves) to ensure the dynamic range/contrast is optimal.

 d) Subtly increase red in highlights and mid-tones using colour balance (no more than +3). In Photoshop CS go to Image> Adjust> Color Balance. This depends on subject, but for most landscapes, particularly with green foliage, I'd recommend this approach.

 e) Add up to 20 per cent saturation (5–15 per cent would be typical) using hue/saturation utility (or vibrance control in more recent programs). In Photoshop CS go to Image> Adjust> Hue/Saturation.

 f) Interpolate to generate a master file. Sizing depends on the quality of the original file, but use the sizes I describe as a guide to the maximum size that might work.

 g) Sharpen your file (unsharp mask in Photoshop). The settings for this depend upon file resolution – experiment. Go to Filter>Sharpen>Unsharp Mask and enter your value. This approach won't improve a hopelessly soft or out-of-focus image. I tend to use 300 per cent sharpening with a radius of 0.3 pixels and a threshold value of 0 for most of my digital camera files that approximate to 8x12in (20x30cm) at 300dpi. For larger files following interpolation or derived from high-resolution scans of transparencies I increase the pixel radius. So for a typical 100MB (approx.) interpolation from a Canon DSLR to yield a 20 to 30in (50 to 76cm) print I might set 300 per cent sharpening with a radius of 0.7–1.0 pixels.

5. Save as tagged image format files (TIFFs), even if originally captured as JPEGs, and archive master files onto DVD and an external drive until needed.

6. Resize master files for printing (inkjet prints at home or commercial top-end laser/LED output onto photographic media) as required.

7. Depending on the system you require, consider software that can index and track your image files.

Sharpening

I prefer to keep in-camera sharpening (and colour enhancement) to a minimum, and do this all myself post-exposure. This is true even for DSLRs. A golden rule is to ensure that sharpening is the very last processing task you do. If you do it early in the process, it creates image-degrading artefacts during any subsequent processing.

cameras do much of this processing on-board, and so it may not be necessary to do this colour enhancement yourself. Indeed, repeating the procedure can ruin a shot.

Applying a cosmetic fix

None of the above effects really alter the image; they simply 'enhance' it. To my mind, they create a digital Velvia. Velvia is the undisputed favourite film of nature and landscape photographers. However, sometimes overt manipulation is required. The best tools to become familiar with in this respect are the cloning tool and healing brush. With the cloning tool, for instance, you can get rid of that annoying chocolate wrapper or footprint you didn't see before tripping the shutter. Care

is required as you clone surrounding pixels into the offending area of the image. The healing brush is a godsend for DSLR users, as it is a quick way to remove dust blemishes that build up on the camera sensor. And here is one very good reason to favour compact cameras – they don't suffer the same ingress of dust that DSLRs do. My full-frame sensor Canon EOS 5D arrived brand new, complete with sensor dust. Full-frame sensors are a real dust magnet, and I rely heavily on the healing brush to negate this problem.

The Photomerge

Panoramic photography is simply fantastic, I have collected together many superb Velvia 6x17cm transparencies over the years using Fuji's GX617 camera, but today I can emulate this classic behemoth with a diminutive compact camera – I still find it hard to accept

This image shows a great street scene. I like the lighting and image density as it is, but the Levels tool in Photoshop is suggesting that I need to darken it slightly by moving the left-hand cursor to the right to meet the beginning of the curve. Usually I go with the Photoshop algorithms, but not on this occasion. To use Levels go: Image> Adjustment> Levels.

the breathtaking quality that is possible with photo-merges. They yield commercially viable fine-art prints that anyone would be proud to hang on their wall.

There are many programs available to stitch images together. Canon's proprietary software that is supplied with its cameras is excellent. Another highly regarded piece of software is REALVIZ Stitcher Express. However, my favourite has got to be the built in photo-merge utility of Adobe Photoshop CS3. It is an amazing piece of software engineering. Go to File> Automate> Photomerge. However, even this utility can become unstuck with turbulent seascapes, but 99 per cent of my panoramics stitch seamlessly with this program.

Remember, it is necessary to shoot subjects using a tripod with a good pan and tilt head and, where possible, to avoid moving subjects. Techniques for generating QTVR (QuickTime Virtual Reality) movies and panoramic images are essentially the same. You need a tripod for both, but there is one item of equipment that can make a huge difference to the success of your work. It's very important that the camera rotates around a pivot point known as the 'nodal point'. This is a point directly beneath the centre of the lens–camera combination. Dedicated QTVR tripod heads have been designed to

overcome this potential source of parallax error, which causes stitching mismatch to occur. One such head is the Manfrotto QTVR 303Plus. This is a large and wieldy contraption, but works really well. However, for the sake of my back, I often leave this at home and use a standard pan and tilt head, which is easy to use with a compact camera and either a spirit level or trained eye to ensure the camera rotates square to both the horizontal and vertical planes.

Monochrome

Digital cameras obviously record images in colour. However, the digital route does provide you with the option of converting your image files into black and white or tinted

The image in this screen grab was originally two separate pictures taken handheld on a compact camera. The final rendering was stitched together using Photoshop's Photomerge capability and was then finalized on my netbook while travelling. To use this facility go: File> Automate> Photomerge. To be able to do this while still overseas is great and means you aren't overwhelmed by postproduction on your return. Also captioning is easier as everything is fresh in your mind.

images at a later date. As with so many things in Photoshop, there are many ways to achieve your artistic goals.

The most obvious route to producing a monochrome image from a colour one is to follow the route Image> Mode> Grayscale. When you have converted the file into a greyscale image you can then adjust the Levels histogram and/or Curves to get the effect you want.

While this method is quick and easy, other people prefer to use the greater control that the Photoshop Channel Mixer confers. Follow the menu path Image> Adjustments> Channel Mixer. This utility in Photoshop CS3 gives some fantastic options, such as a black and white infrared preset. I used this to create the sepia image of Banteay Samre and Ta Prohm shown earlier.

Simple mono conversion

For a simple monochrome conversion, in the Channel Mixer dialogue box select the monochrome tick box and adjust the red and blue channels till you get the result that pleases you most. The total percentage of red and blue channels should add up to 100.

Many compact cameras can record directly in monochrome, but this removes options – I always shoot in colour and then convert to black and white post-exposure.

Monk with umbrella.
I converted the image to sepia via Image> Adjustment> Black & White, selected tint and then played with the Curves until I was satisfied.

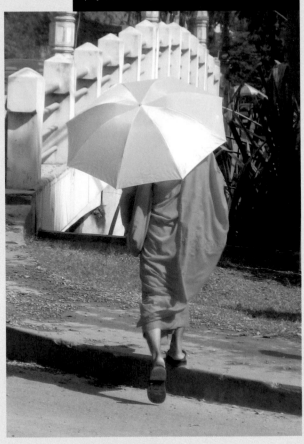

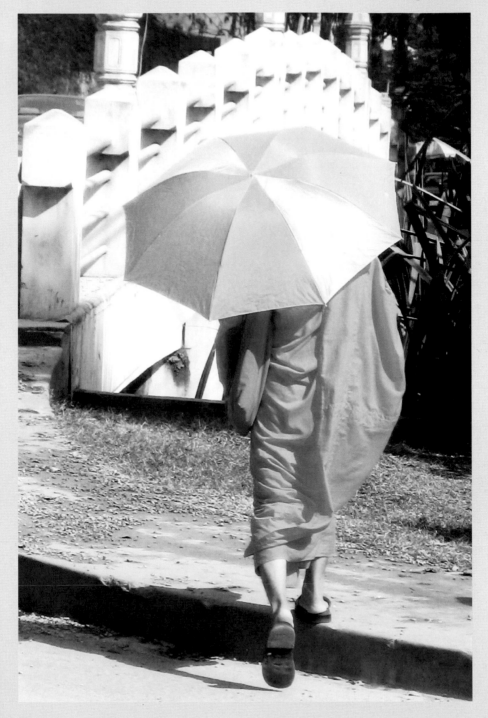

The end product

The important thing about your photography is that you enjoy it, and that it constantly challenges you with new goals. Even if your sole camera is a compact, there is so much you can do with your images in this day and age.

- You could sell your images to suitable magazine and book publishers

- You could make them available on the web to potential clients through some of the more popular image hosting sites

- You could add words to your pictures to produce a package (photo essay) that is more likely to sell to a magazine or local paper than either words or pictures alone

- You could use your images in an audio-visual presentation – i.e. a slideshow using the latest generation of digital projectors

- You could use them for teaching purposes if you are in the education sector – i.e. in PowerPoint slideshows

- You could use them to construct a website, or make them available for others to do this on your behalf

- You could use them online for striking, dynamic Flash™ presentations

- You could post them on the web to keep people informed of your progress if travelling

- You could print them off and hang them on your wall, or sell them to others who might like to hang them on their wall

- You could use them to illustrate a book and attract a potential publisher (as I have here!)

Publishing has changed in recent years. If you think you're a good photographer and have not yet been published, proclaim yourself and your skills via your own website. My site has several sections, but I guess one of the mandatory pages for everyone is the biography, which is reproduced here via a screen grab.

- You could self-publish a coffee-table book using one of the many online companies that now supply this service. Some of these companies produce amazing-quality products

- You could set up an exhibition of your work in a local gallery or coffee shop

- You can illustrate newsletters, information sheets or other literature in the form of pdf files that people can download freely (or not) from the web. For instance, I did this for a guide to the local flowers in my part of the world

- You could produce visually stunning wallpaper for your computer desktop

- You could experiment with Quick Time Virtual Reality (QTVR) presentations – increasingly popular with estate agents

- You could experiment with time-lapse photographic techniques

- And let's not forget the more obvious uses, such as capturing family and friends, and emailing pictures to people.

Enjoy your photography, and recognize that today's compact camera can take really outstanding pictures – your imagination, and not the technical prowess of your camera is the only limiting factor to your success. Good luck!

One of the best ways to display your work is with simple Flash™ slide shows. You could use html slide shows, but Flash™ is more polished and makes it difficult for people to copy your images (albeit small versions). The two images here are grabs from two Flash™ shows on my website. It's also easy to drop in audio or to add some text to Flash™ slide shows. The nice thing about this format is that it's dynamic and helps to focus the viewer's attention.

Glossary

Autoexposure
Depending on the specific model, autoexposure can mean the camera takes over complete control of exposure (i.e. the balance between light entering the camera due to shutter speed and that entering through the lens aperture). This can also include setting of sensor sensitivity (ISO) and automated use of flash. Alternatively it can refer to partial automation of exposure with the photographer electing how much control to relinquish. It is sometimes referred to as 'program' or 'auto' mode.

Autofocus
The camera decides where to focus based on complex algorithms and several possible autofocus points within the frame of view – often this can be overridden by electing a single autofocus point for manual control. A recent innovation includes facial recognition algorithms that can identify suitable focus points based on the presence of a person or person's face(s).

Battery
Chose a camera that offers long battery life; either rechargeable Li-ion or easily obtained AA batteries. When travelling it's usually very easy to track down AA batteries.

CF card
Compact flash memory card.

Colour
Unlike DSLRs, compact cameras have a tendency to pump colours up due to proprietary inbuilt software. This isn't necessarily a bad thing, but means that if you use postproduction editing you have to be conservative with such things as adding saturation. The colour profile used is typically sRGB, the same as used in computer monitors and home printers. However, the profile Adobe 1998 has a wider gamut and I often convert my files to this – beware though, if you do this you may need to desaturate before printing.

Compression
Image files in the JPEG format take up less room than TIF files (see below) because they compress data. This is fantastic where storage is limited, but every save cycle leads to a marginal degradation of image quality. This may be of little concern to most compact camera users, but serious photographers will probably convert to a TIF file for long term storage once back at home.

Digital zoom
This is more gimmick than anything else, and not something to influence buying decisions. Basically all this does is to crop into your base file to 'appear' as if it is magnifying the scene as if you had a telephoto lens attached. In reality all you

are doing is magnifying pre-existing pixels. Pictures taken using this option often look dreadful and badly pixellated.

Download
Transferring of image files from camera or memory card to your computer via a USB cable. Card readers are an important accessory and are often like Swiss army knives in having the utility to handle different card formats i.e. SD, memory stick or CF etc.

DPOF
Digital print order format. Allows selection of images for printing using a commercial service that supports this format.

Erasing
Individual image files can be deleted. Take care not to remove valuable files. See also formatting.

Exposure
Making a picture by exposing the sensor to light.

External hard drive
Two basic forms of external hard drive exist – small USB-powered devices that are ideal for travel, and larger mains-powered drives of larger capacity that are best for long-term archiving.

File number
Every image file has its own unique file number. These can be overwritten with a more apt, user-friendly description.

Flash

Flash is generally adequate for purpose on compact cameras, but can struggle at times. The best use is when it's deployed as a fill in and not as the sole or major light source. Some compacts allow you to use separate flashguns which might prove useful to some people.

Focus

See autofocus

Focus lock

If you want a particular part of a scene to be in clear focus, it's often possible to switch to single-point focus, depress the shutter half way down with the single focus point aimed over your subject, then recompose the scene to best effect (keeping your finger on the shutter button). When you're happy with the composition, depress the shutter fully to take the picture. This technique is known as focus lock, and is very useful when using a compact camera.

Formatting

When you have filled a memory card with images and downloaded them to your PC, CD/DVD or portable hard drive, you should reformat your memory card to begin the cycle of image capture anew. Two points: don't delete images one at a time (time waste) and only ever format your memory card in the camera in which you propose using the card.

Functions

So many novel functions exist, it would be silly to try and list them all. Suffice to say try to discern genuinely useful functions from silly/pointless ones.

Histogram

A histogram is a simple graph that shows the distribution of pixels in an image by graphing them according to intensity. It shows whether an image has sufficient detail in the shadows (left segment of histogram), mid-tones (middle segment) and highlights (right segment). It helps evaluate an image file via the camera and also in post-production software. Many cameras may not have this facility – higher end ones may. Use exposure compensation until the graph approximates more or less to a bell-shaped curve.

Interpolation

A technique that allows the enlargement of an image file to produce bigger prints. Special software (i.e. Extensis pxl SmartScale/Genuine Fractals) that can plug in to programs such as Adobe Photoshop can help grow pixels so larger prints are possible. However, later versions of Photoshop are highly competent at interpolation without additional software. There are limits to what is possible; the inherently better files of a DSLR interpolate better than a compact camera file of equal 'megapixels'. To give you an idea of what is possible without degrading an image, a native 6-megapixel DSLR file taken with a good lens and low ISO can be interpolated to print at 24in (60cm) on its longest side.

This is the maximum; I find my 10-megapixel compact can yield a similar-sized print on occasion. 24 inches is stretching it and 20 inches (50cm) is more realistic.

IS

Stands for image stabilization which is a mechanism to reduce camera shake via movement of one of the lens elements as a corrective measure.

ISO

ISO number describes the sensitivity of a sensor to light. The lower the number the less sensitive it is (i.e. great for bright conditions); the higher the ISO, the more sensitive it is (great for dim light). In reality, most compact cameras are dreadful at high ISO due to copious noise in image files. There is no question that base ISO (80 or 100) produces the best images in terms of low noise. The increased noise arises from small, crowded photosites that cope poorly with the increased signal amplification that comes with setting a higher ISO. ISO stands for International Standards Organization and is analogous to ASA, used at one time to define film speed (sensitivity to light). So increased noise at high ISO equates to a grainier image as was once seen with fast film.

JPEG

Stands for Joint Photographic Expert Group and is the standardized file format generated by most digital compact cameras.

LCD monitor

Stands for liquid crystal display. It's far easier to compose a scene via an LCD screen than it is through a viewfinder – especially if the screen is articulated and so can be angled into just about any position. This is great for very low or very high vantage points and means you yourself don't have to get too low or too high to execute a shot. Be aware – your LCD screen is a major drain on your battery, and using it for extensive reviewing may not be a good idea if battery life is low or replacements not easily found.

Lens

Most compact cameras have surprisingly good lenses – read online reviews to check out the best glass.

Lens conversion kit

The majority of digital compacts do not achieve true wideangle or telephoto perspectives. I suspect to do so would compromise lens design or price. However, many manufacturers offer bolt-on adapters that permit these extended perspectives. They are not always that compact, but produce very high-quality results.

Macro

Different compact cameras offer different macro (close-focusing) capabilities. This, to my mind, is one of the greatest attributes of a compact camera and would be the first thing I'd check if buying a new camera. The results can be truly amazing – even for wildlife.

Manual

Some cameras offer full manual control of aperture, shutter speed, ISO and flash. Others do not. Beware, some manufacturers use the term manual when exposure is actually automatic, although some rudimentary control of exposure is possible.

Memory card

Small device for recording and storing image files. Such cards should be considered as a temporary measure prior to permanent archiving on optical or external discs/drives. Different formats exist such as CF, SD, memory stick etc. A cheap 2Gb card is ideal for a 7-megapixel camera – the battery will likely drain before the card fills.

Menu

A navigation mechanism that allows you to interface with the various features of your camera. Simple is always best with menus – if the menu is too complex you might miss the shot!

Microphone

A necessary feature if your camera can record video.

Movie

Cameras are moving towards a convergence of still and moving image capture. Modern cameras offer different formats; two examples are AVI and MPEG. Movies captured are surprisingly good and are set to improve further with the incorporation of high-definition recording at 720p and above.

Night photography

Traditionally the realm of larger cameras, it is possible to take surprisingly good long exposures with a compact camera. Select a camera that can open its shutter for 15 seconds – many cameras cannot. Avoid high ISO, switch off your flash and use a tripod; shoot in manual mode if you can. People photography at night will, however, generally require flash.

Panoramic shooting

Panoramics can be easily constructed from two or more images via the photo-merge feature of Adobe Photoshop or via proprietary software that sometimes comes with your camera; however, many programs from other software manufacturers are available. In essence you take two or more images that overlap by around 30–50 per cent and blend them into a single image file with a wide field of view.

Pixel

The fundamental unit of an image; a 10-megapixel camera will record 10 million pixels of data. More pixels do not necessarily equate with better images. This is because with the small sensors found on compact cameras noise becomes limiting.

Postproduction

Refers to the act of editing images using software after capture. The industry standard is Adobe Photoshop, but there are many other admirable programs available

at a lower price point. Adobe Lightroom is also a popular product that is getting good reviews, and which is particularly easy to use if you are new to photography.

Red-eye reduction

A pre-flash is used to contract the pupils of your subjects' eyes so as to reduce the red reflection from the retina at the back of the eye.

SD card

Secure digital memory card. Now available as an HC (high-capacity) variant. Probably the most popular type of memory card.

Self-timer

This usually exists in the form of a two- or ten-second delay. This is really useful for long exposures to avoid camera shake, but only for a well-supported/braced camera. In this case two seconds is ideal. For self/group portraits the ten second timer is best.

Shooting mode

Depending on the camera the following modes might be available: TV (shutter priority), AV (aperture priority), M (manual), P (program) and A (automatic).

Shutter

This term is given to the curtain or iris blades that open and close to expose the sensor. It works in concert with a lens's aperture and ISO setting to deliver the appropriate quanta of light to the sensor. The button that trips the shutter is sometimes wrongly referred to as the shutter.

Slow-sync

In low light the best results are sometimes obtained by using a long shutter opening in concert with a brief burst of flash to balance the ambient light. This is referred to as slow-sync and is possible with most cameras, including many compact cameras.

Spot AE/focus

See autofocus above; the defined focus spot is often tied in to exposure metering.

Stitch assist

See panoramic shooting; stitching is the act of merging two or more images into one with a very wide angle of view.

Telephoto lens

A telephoto lens is used for bringing distant subjects closer. The negative aspect is that maximum apertures are smallish and so matched shutter speeds are longer with more likelihood of blur. This is where image stabilization becomes very useful.

TIF/TIFF

Tagged image format file; uncompressed and generally large file format that is ideal for archiving important image files. It is the industry standard in publishing and printing.

Video

An option on most digital compact cameras; common formats include AVI and MPEG (see movie above).

White balance

If this option is present it can be used to correct for colour casts caused by tungsten, fluorescent, cloudy or sunny lighting.

Wideangle

A wideangle lens takes in a broad vista and is ideal for group shots, confined spaces and landscapes.

Workflow

Workflow refers to the process of capture, downloading to a computer, selection, editing and storage. Other steps might include uploading to a website.

Zoom

A zoom is a variable focal length lens. Generally the longer the focal length range the greater the optical compromises that have to be made in its construction. However, in my experience digital compact camera zooms are remarkably sharp, high-quality optics.

Further reading

Photography and travel go hand in hand. However, for many people the passion of travel and discovery transcends the camera. To fuel this fire, I'd like to recommend a handful of the best paperbacks on travel and adventure that I have read in the past few years. They should fit easily in your camera bag or rucksack next time you go on a jaunt, and will inspire, educate, thrill and whet your appetite for next year's foreign trek. Bear in mind, though, they do not deal with photography in any shape or form, but do kindle the spirit of travel photography in those of us genetically susceptible to this genre.

Blue Nile: Ethiopia's River of Magic and Mystery, by Virginia Morrell (Adventure Press)
The Old Patagonia Express: By Train through the Americas, by Paul Theroux (Mariner Books)
The Great Railway Bazaar, by Paul Theroux (Mariner Books)
Dark Star Safari: Overland from Cairo to Capetown, by Paul Theroux (Mariner Books)
At the Mercy of the River: An Exploration of the Last African Wilderness, by Peter Stark (Ballantine Books)
To Timbuktu: A Journey Down the Niger, by Mark Jenkins (Modern Times)

I've enjoyed every one of these titles, which have helped while away the hours on train, plane and at airport, and recommend them to others with an interest in travel, culture and the wider world.

About the author

Mark Lucock was born in 1958 and grew up in Suffolk. After graduating from university with a degree in Applied Biology, he obtained his PhD in 1991 and is an elected Fellow of the Institute of Biology and a Chartered Biologist. Mark moved from the UK to Australia and the scenic New South Wales Central Coast in 2003.

Whenever he gets the opportunity, he is out photographing the natural world. His work features a range of destinations – including the UK, India, Southeast Asia, Australia, North America and much of Europe, and reflects the broad spectrum of nature and landscapes from around the world. He uses all manner of cameras from large-format and panoramic film cameras to Canon DSLRs, but the most fun and certainly the most often-used cameras are his Canon compacts – lightweight, unobtrusive and always at the ready.

Mark has had many publications in the popular press. His first book, *Photography for the Naturalist*, was published by GMC Publications in February 2002. This book, which is lavishly illustrated, covers the technicalities and aesthetics of shooting all kinds of animal, plant and landscape images. Mark's second book was released in February 2003 and is titled *Professional Landscape and Environmental Photography: From 35mm to Large Format*. This book again deals with technicalities and aesthetics, but looks at photography in all manner of environments, from steamy rainforests and dry deserts to bustling cityscapes at night. His third book, *Succeed in Landscape Photography*, was released in October 2004. This book is published by RotoVision SA. His most recent book, published in October 2007, examines issues associated with digital photography such as workflow, image editing, marketing, web design and, of course, camera craft. The book, *Digital Nature and Landscape Photography*, was published by The Photographers' Institute Press.

Recommended websites

UK-based nature/landscape photographers

Peter Adams	padamsphoto.co.uk
Niall Benvie	imagesfromtheedge.com
Steve Bloom	stevebloom.com
Laurie Campbell	lauriecampbell.com
Richard Childs	richardchildsphotography.co.uk
Joe Cornish	joecornish.com
Tom Mackie	tommackie.com
Phil Malpas	philmalpas.com
David Noton	davidnoton.com
Colin Prior	colinprior.co.uk
Andy Rouse	andyrouse.co.uk
Charlie Waite	charliewaite.com
David Ward	into-the-light.com
Peter Watson	peterwatson-photographer.com

Australia and New Zealand-based nature/landscape photographers

Andris Apse	andrisapse.com
Peter Dombrovskis	abc.net.au/tv/wildness/gallery.htm
Ken Duncan	kenduncan.com
Peter Jarver	peterjarver.com
Mark Lucock	marklucock.com
Leo Meier	leomeier.com
Nick Rains	nickrains.com

North American-based nature/landscape photographers

Theo Allofs	theoallofs.com
Ellen Anon	ellenanon.com
Alain Briot	beautiful-landscape.com
Christopher Burkett	christopherburkett.com
Clyde Butcher	clydebutcher.com
Charles Cramer	charlescramer.com
Bruce Dale	brucedale.com
Jack Dykinga	dykinga.com
Michael Fatali	fatali.com
John Fielder	johnfielder.com
Michael Hardeman	michaelhardeman.com
Robert Glenn Ketchum	robertglennketchum.com
Frans Lanting	lanting.com
Thomas D Mangelson	mangelsen.com
Joe and Mary McDonald	hoothollow.com
Art Morris	birdsasart.com
David Muench	muenchphotography.com
William Neill	williamneill.com
Galen Rowell	mountainlight.com
John Shaw	johnshawphoto.com
Tom Till	tomtill.com
Larry Ulrich	larryulrich.com
Art Wolfe	artwolfe.com

Index

To place an order, or to request a catalogue, contact:
Ammonite Press
AE Publications Ltd, 166 High Street, Lewes, East Sussex BN7 1XU
United Kingdom
Tel: 01273 488005 Fax: 01273 402866
www.ae-publications.com
Orders by credit card are accepted